painting
all aspects
of water

for all mediums

by e. john robinson

international
artist

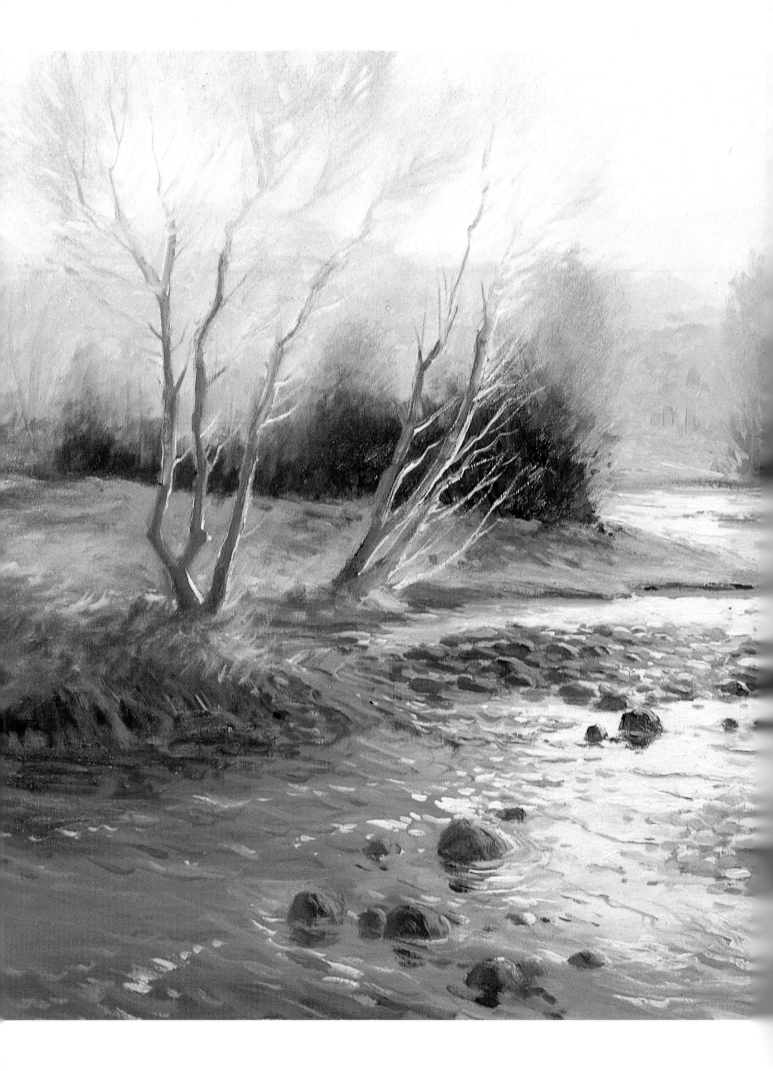

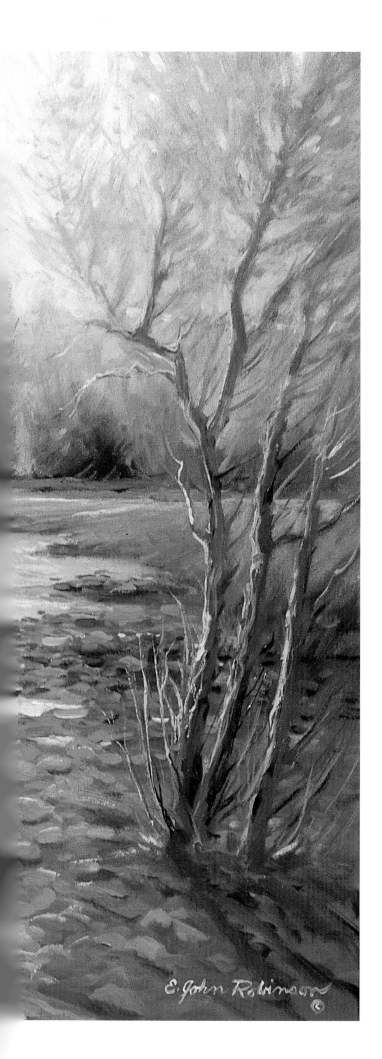

painting
all aspects
of water

for all mediums

by e. john robinson

international
artist

international artist

International Artist Publishing, Inc
2775 Old Highway 40
P.O. Box 1450
Verdi, Nevada 89439
Website: www.internationalartist.com

Edited by Terri Dodd
Design by Vincent Miller
Typesetting by Ilse Holloway

 ISBN 1-929834-38-1

Printed in Hong Kong
First printed in hardcover 2004
08 07 06 05 04 6 5 4 3 2 1

Distributed to the trade and art markets
in North America by:
North Light Books,
an imprint of F&W Publications, Inc
4700 East Galbraith Road
Cincinnati, OH 45236
(800) 289-0963

dedication

To all who love nature and are
compelled to express its moods.
— E. John Robinson

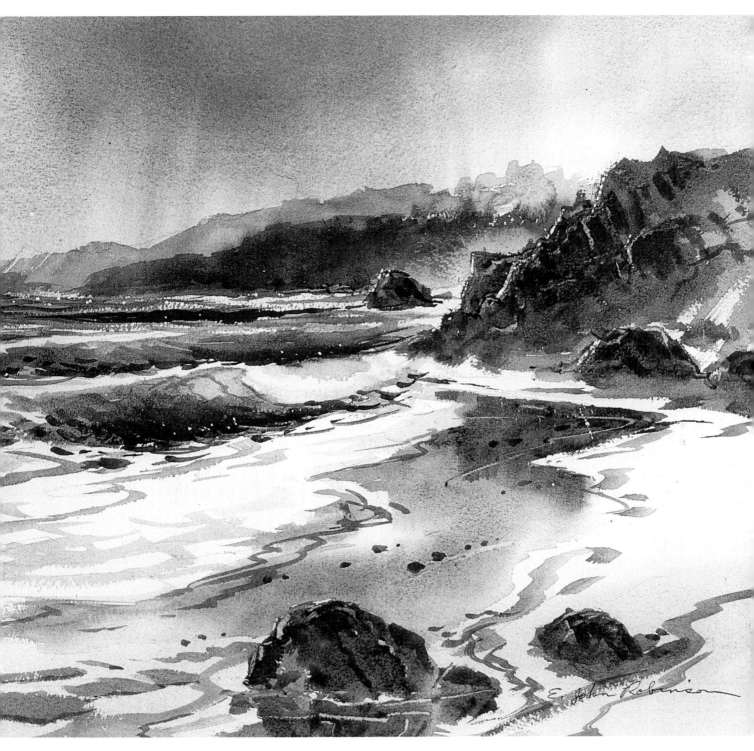

Rain to the North, watercolor, 14 x 20" (36 x 51cm)

table of contents

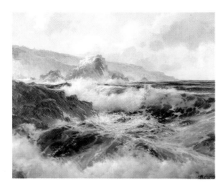

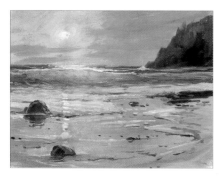

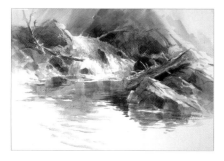

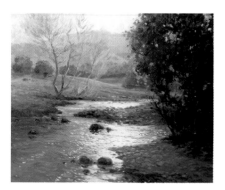

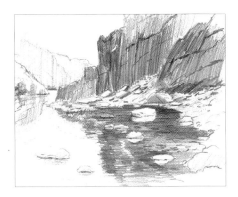

Lakes and ponds can be either shallow or deep, but they nearly always reflect what is around them. This gives you the opportunity to add mood to a painting that could otherwise be difficult to achieve.

step-by-step demonstration
reflecting soft colors and edges to create a relaxing, restful mood — in oils

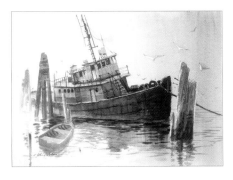

There's a mystical, magical quality about rivers. Once you understand this you will be able to create paintings full of drama and meaning.

step-by-step demonstration
suggesting distance and mood — in opaque watercolor

The most crucial things to introduce into your waterfalls are shadow and color.

step-by-step demonstration
handling sunlight and shadow in a waterfall — in watercolor

Because they reflect the sky, the important thing to remember about these busy places is to reflect the sky first, then introduce the other objects.

step-by-step demonstration
suggesting downlighting in a busy harbor scene using oils

The sea is the greatest reflector of all, and it allows you to paint countless moods.

step-by-step demonstration
moonlight reflecting off translucent waves — in oils

introduction

Water — the most used, but least understood, of all the elements we paint.

We all realize that water is vital to our existence. In fact, without it, life as we know it would cease to exist. Water covers about 71 per cent of the earth's surface, so it is no wonder that it appears in so many landscape paintings, not to mention pure seascapes.

Water can be an **element** in a painting in the same way as the sky, or atmosphere. It can be an **incidental area** that reflects color or adds to the mood; or it can be the **subject** of the painting in the form of a creek, river, pond, lake or waterfall. Whichever way water is included, it is probably the most used but perhaps least understood of all the things we paint.

Water is a reflector of light and color
Water can take on so many forms: from atmospheric droplets of mist and fog to rain, snow, ice, streams, lakes and oceans. But the most important feature of water is its **reflective quality**. Any still body of water can reflect a nearly mirror image of anything around it. Moving water, where reflections are broken by wind, waves or current, give us the opportunity to play with many beautiful light effects. If you want to see some outstanding use of water in art, look up the work of the the French Impressionists, who liked nothing better than painting the effects of reflected light and atmosphere on water.

Water is a color and mood conveyor
Water can also be a conveyor of **color** and **mood**. If a composition needs some balance of color from the sky to the foreground, then a well-placed puddle, or small body of water, will reflect and therefore add color just where it is needed.

Water can convey mood simply because of its form, that is: rushing, meandering, quiet and deep, muddy, confused, falling, stale, health-giving, destructive . . . just about any of the moods we humans experience. Going further, if you combine any of the water forms with a certain play of sunlight or shadow, or that other important element **tone**, you can convey a happy, sad, angry or mysterious mood.

What I'm going to teach you about water
The purpose of this book is to give you knowledge of water and its special properties, and to show you examples of the limitless ways it can be used in your paintings.

I have divided the book into three sections:

- We begin with the vital ingredients, by looking briefly at the materials and supplies best suited for painting water in a variety of mediums. Then I'll show you examples of water's properties, its reflective qualities and how you can use water to convey different moods.

- Next, I'll show you how to use water as a background, or incidental, in a composition. This includes things like wet ground, wet streets, moody skies, mud puddles, tidal pools and even containers of water.

- The last section of the book deals with water as a main subject: Here I'll show you how to paint creeks, lakes and ponds, rivers, waterfalls, bays and harbors. Then we'll finish with some essential infomation about painting the surf.

My aim is to give you an in-depth look at mood, color, tone and composition. To help you, I have included several step-by-step demonstrations and examples that you can do yourself that reinforce the teaching in each chapter.

The keys to fine art painting
Please keep in mind that this teacher of art believes very strongly that knowing your subject in depth will help you improve — no matter what level of artistic development you have reached.

I also believe that if you do more than just copy a scene you will produce paintings that will be miles ahead of most others. If you can add mood to an otherwise so-so painting you will have lifted it from the realm of "postcard" and brought it up to the category of "fine art". **Fine art is an expression more of the artist than it is of the subject**. Therefore, the more you know and the more you can convey what you feel, the better your paintings will be. In the meantime, learning to perceive and then learning to express yourself is the most pleasant journey a person can take.

E. John Robinson

***Forest Creek*, oil, 30 x 24" (76 x 61cm)**

E. John Robinson

equipment and supplies

Artists are spoiled for choice when it comes to buying materials — and most decisions come down to personal preference. Here, I'll list the materials I use in various mediums, in the hope it will serve as a guide.

When it comes to equipment and supplies most artists experiment to find out what suits them. I will show you my equipment and the colors I prefer and you can make up your own mind.

While I caution you not to think that the latest, greatest or most expensive materials will help you make masterpieces, I do recommend that you buy quality brushes, artist's quality paint and a good surface on which to work. Nothing can be more frustrating than watercolor paper that wrinkles, oily oil paint, watercolors with weak pigment content, or brushes that leave behind more hairs than pigment. Give yourself a break when it comes to buying those items, and use what works best for you.

oil supplies for the studio and in the field

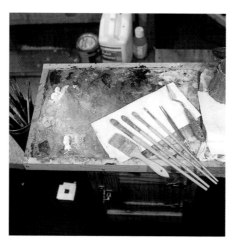

studio easel
I use a large studio easel because I often paint large canvases and I don't want the easel to shake or move. My easel cranks the canvas up or down and holds it firmly in place.

There is a multiplicity of easels on the market in a wide price range, suitable for a wide range of mediums. The first thing to think about is how you work and the space you have available, because some can take up quite a bit of room.

An easel should be sturdy enough to support your work without danger of falling over.

Look for hardwood, steel or aluminium easels with heavy metal fasteners and the versatility to handle a variety of sizes and weights.

Some easels allow you to pivot them so you can use them upright for pastel or oil painting or horizontal for watercolor work.

studio palette and brushes
I believe there are as many different palettes available as there are artists. I made my palette from a slab of marble held on a piece of plywood. You can use paper palettes, (but they don't always stay put when you are mixing), glass, wood, or metal. Whatever you use it should not become gouged when you clean it.

My brushes are both flat types, (brights) and filberts. Filberts are flat but the bristles are longer and the corners rounded off. I use #'s 2,4,6,8, and 10. For tiny work I use round sables #'s 000,00,0,1, and 2. You can use synthetic brushes if you wish. I keep my brushes clean by rinsing them in mineral spirits which to me, doesn't smell up my studio as much as turpentine. It is also cheaper, but remember to have good cross ventilation anyway.

studio lighting
I use track lighting similar to that used by galleries. You can also get lighting that mimics the qualities of daylight so you can keep working into the night!

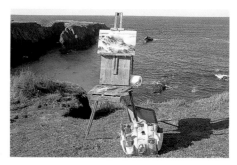

field oil equipment
I use a fold-up French easel of good quality and it contains a wooden palette. (These easels suit watercolorists too.) I carry a bag with extra paints and a container of paint thinner. I prefer standing up when painting in the field.

Outdoor easels should be reasonably portable and easy to set up. Once set up they should be stable. If you choose a folding metal easel make sure you don't dent the legs, because the telescopic action may suffer. Often the most secure outdoor easel is one with a folding centre support attached to the three legs.

watercolor supplies for the studio and in the field

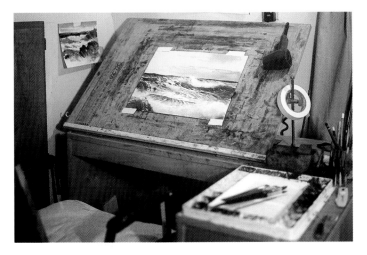

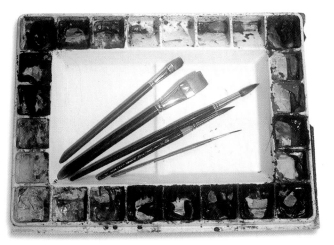

studio worktable
I built my own watercolor worktable so that I could sit down to paint. The top tilts to any position I want, and it has an L-shape which allows a place by my side for the palette. Near the palette is a well for a jug of water, holes for brushes and space for towels and a sponge. The "L" has drawers that hold my tubes of paint, brushes, and other odds and ends. In addition to that, I have a hair dryer for when I get a bit impatient with drying time. I use the same studio lighting as I do for my oil painting.

watercolor palette and brushes
I use a commercial plastic watercolor tray. It is deep, has plenty of wells for paint, two large mixing areas and it closes up to help keep pigments fresh. It fits nicely on my work table and is just the right height when I am sitting down.

I will say here that I prefer tube watercolors over those little pans of hard pigments. I keep my colors fresh by sponging water over them and I frequently add fresh paint as well.

My brushes are good quality sable brushes. The rounds are #'s 4 and 12 and both come to a fine point when wet. The flats are ½" and 1", and I also use a 32 or liner brush at times.

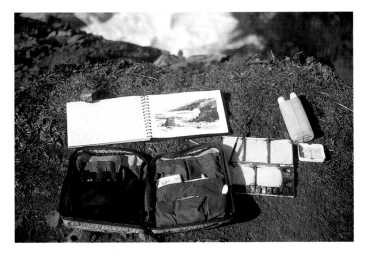

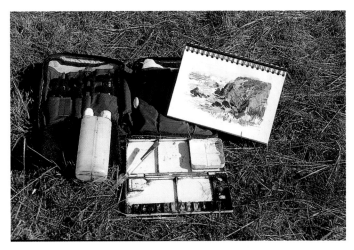

watercolor field equipment
I have two field kits: one is an aluminum fold-up easel and I place a palette like I use indoors on a fold-up TV tray. It is large enough for a jar of water and a sponge as well. I have a tote bag with supplies and a board to hold a sheet or a half sheet of paper.

I tend to paint only small sketches in the field, especially when traveling. I sit on the ground, or on a piece of plastic, and use a small kit that contains everything a large one does. I use blank journals made from watercolor paper and make notes as well as quick sketches.

other materials

acrylic

Acrylic paint is so close to oils in technique and colors that I will not make them a separate issue.

Acrylic paint is a cross between oil and watercolor. It can be thinned to produce delicate transparent watercolor-type washes. (In fact, acrylic paint tends to dry the same color, unlike watercolor that fades when it dries.)

To keep your acrylic paint usable for longer, fold some hard-surfaced paper towels on the bottom of a tray and soak with water. Then squeeze the acrylic pigments on top.

Acrylic can also be mixed with mediums to give a dense, buttery, impasto thickness.

Because many oil painters begin their works with quick drying acrylic paint and apply the later stages in oils, the same colors can be found in the oil and acrylic ranges. Acrylic brushes (bristle and/or soft sable) wash out in water, and you don't use turps.

pastel

Pastel is a wonderful medium and you will see a number of pastel illustrations in this book. I enjoy some of the effects that can be achieved with either soft pastels or oil pastels.

Powdery soft pastels can be used on their side to block in big areas of color. Many artists use the edges of the harder ones to add detail or when they are using specific techniques like cross-hatching.

Pastels can be used with other mediums. Soft pastels can be combined with watercolor paint to give interesting effects. Oil pastels can be used in conjunction with oil paints, or on their own.

Whichever type of pastels you use, the important thing to realize is that you don't mix pastels to get a new color — you choose the exact color you want from the huge range of colors available. That's why I suggest your pastel kit should contain as many colors as possible. There are several landscape sets available that offer the main intense pigments, as well as all the lighter tints. Be sure to have a fixative and erasers on hand.

pencil

If you fancy pencils, you will need a good array of them. There are many types available, from hard to soft, from pointed to flat — like a carpenter's pencil. Use good paper and include fixative and erasers in your kit.

You can produce excellent results with colored pencils, but building up the layers on a major piece is time-consuming. They are excellent for on-site sketches. Like pastels, make sure you have a good variety of colors because getting the right color is less easy than with watercolor and oils.

Also experiment with pastel pencils and watercolor pencils.

surfaces

canvas for oils and acrylics
I use a primed linen stretched over wood strips. However, I recommend cheaper cotton or canvas boards for learning and experimenting. There are different "weave" surfaces available, so try them out to see which you prefer.

plywood boards
For outdoor sketching I coat different sizes of ¼" plywood with gesso. For detailed work, I give the board two or even three coats and sand each coat down for a smooth surface.

paper for watercolors
As I mentioned before, paper that wrinkles is a frustrating experience. For larger watercolors I use 300lb (638gsm) paper with a fairly rough surface that never wrinkles. 140lb (300gsm) paper is also good but should be stretched. It can be soaked in water then taped or stapled to a board. As it dries it shrinks and the result is very little wrinkling. For smaller paintings I either cut different sizes from heavy paper or I use a watercolor block. For the most part paper in blocks does not wrinkle much.

paper for pastels
There are special papers for pastels that come in several sizes and colors. Sanded papers are available that grab the chalk more readily. You can also buy pastel primer that allows you to coat paper with a textured surface, and because it comes in different colors you can choose the best toned background to enhance your work.

Try these different options and decide what you like best.

colors

watercolor paint

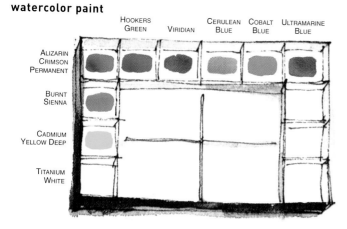

oil colors

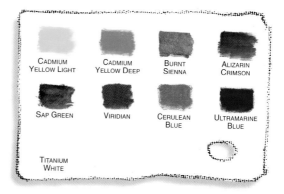

I work with a limited palette of colors in oils/acrylics and watercolor, usually six or seven colors plus white, and I mix them to get almost any color I want. Color choices are up to the individual artist. If you are a student I suggest you try them all and then work with those that you prefer. Color is one way to individualize your work.

In some cases the subject demands certain colors. For instance, portraits require colors that are compatible with skin tones. Seascapes look better when they are painted with more transparent blues and greens such as Ultramarine Blue, and Viridian or Phthalo Green.

Landscape colors vary from area to area. The main thing to remember when working in watercolor, oil or acrylic is that you don't need a truckload of colors. Learn which colors suit your preferences, your subject and your locale.

In this book I list all the colors I use in the step-by-step demonstrations. You can choose to follow these colors or not. Remember, they are my choices — you may like them and follow them, or you might want to substitute your own colors.

chapter 2

properties of water

Understanding your subject is essential to the success of any painting.
I will remind you of that frequently, because it really is that important.

When I was a new art student, I remember sitting with others in the freshman class all eagerly, but unsuccessfully, trying to draw a model. Our teacher was very patient and let us fumble for a day or two. Then he introduced us to human anatomy for the artist. It was slow learning, but in time we understood the human form, its bones and muscles, and our drawings became not only more accurate but more professional as well. This principle of thoroughly understanding the subject applies to everything you paint: trees, seascapes, rocks, buildings — anything that has form, or what I call "properties".

Water has characteristics that other forms do not have. With the exception of waterfalls and runoffs, water is always level. Water changes shape to fit into spaces. It acts as a reflecting agent. You can sometimes see through it and, of course, it moves. Because it can reflect what is above or around it, water is an invaluable aid to a composition. Water can give you the excuse to repeat a color or value for better harmony. Water can be used to break up an uninteresting shape. Above all, water can help carry a mood.

I consider mood to be as important as any other ingredient in a composition and this makes water a special addition to a painting. That's not to say all paintings should have some form of water in them; it simply means that the use of water, either as a subject or an aid, will give any painting a greater dimension. This chapter then, is vital to your understanding of the subject so that you can use water more successfully, and with greater skill.

shallow water effects

Water can be very interesting when it is shallow because it is more transparent than deep water. When water is shallow enough we can see the ground beneath and rocks and pebbles will be visible. This gives you a chance to introduce new colors and values and to add textures as well. The tricky thing is to indicate the surface of the water correctly. Some ways to do this are to reflect a path of light, add some objects or have a section of it reflecting the sky. You can also add sparkle, glare, or some horizontal reflected lines that pass over the shapes beneath.

(Right) *The Beach at Midday,*
oil, 30 x 24" (76 x 61cm)

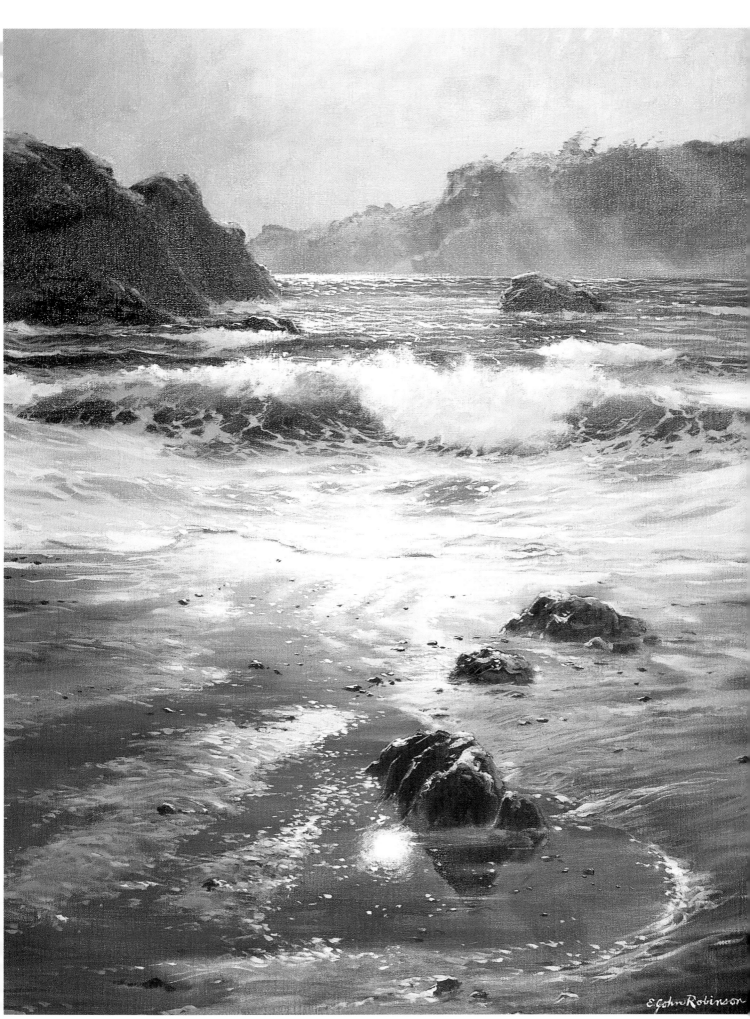

E. John Robinson

reflections

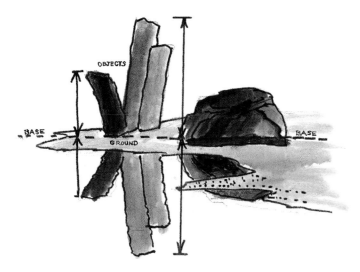

the mirror image

When water is smooth and flat and we look straight at objects above and beyond it, the reflected image will usually be an exact duplicate of the objects.

Notice how a slanted object reflects in the opposite direction but is still coming to the viewer.

In the following illustrations you will see that there are variations of the mirror image.

keys to the mirror image

1. The reflection will carry the colors, values and shapes of the objects.

2. Remember that reflections always come to the viewer; they do not go off in other directions except as the image of slanted objects.

3. The size of the object is measured from the top to its base and the reflection is measured from the base to the end of the reflection. Any ground below the object obscures the reflection — so remember to measure the reflection from the base of the object and NOT from the edge of the ground, which can be any size or shape.

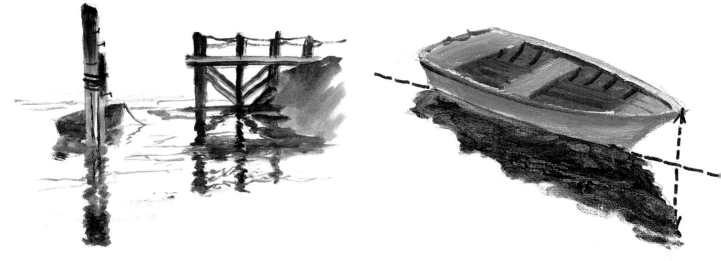

rippled reflections

Ripples from wind or some other activity like tidal movement, distorts the mirror image. The reflections are still measured from the object's base downward, but the edges of the reflections are wavy or rippled. Stronger rippling will break up the reflections, introducing sky and other background colors.

reflections viewed from above

Another variation on the mirror image is caused by perspective. If we are above an object looking down on it, then the base is different. Our eye level is not straight ahead. In this case if the water is under an overhang such as a boat, it will reflect or "see" more than we do. It's like holding a mirror under your chin. Notice that when we look down on the boat the reflections come straight down, or to the viewer, but the water "sees" more of the hull than we do and the reflection is extended.

extended reflections

Very strong rippling of the surface will extend the reflections beyond the mirror image. In this illustration you can see how areas of the reflection are bouncing off choppy water. The chop reflects the object that is out of our view, but its reflection bounces to the face of the next chop, which we can see. Once you understand this principle, you will not make the mistake of painting over-extended reflections in smooth water.

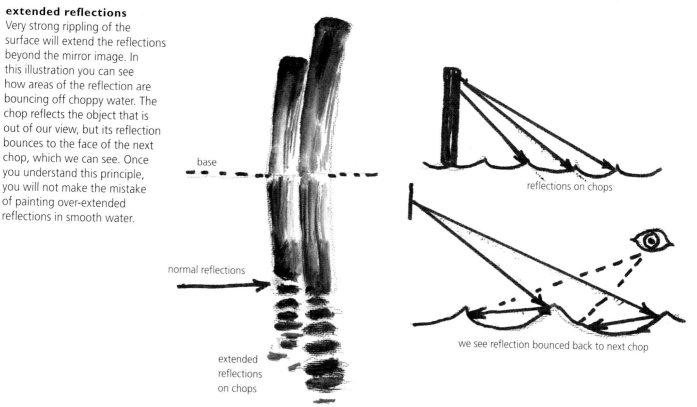

base

normal reflections

extended reflections on chops

reflections on chops

we see reflection bounced back to next chop

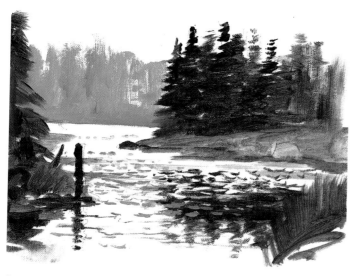

lost-and-found reflections

When chops or activity occur it may not be over the entire surface of a body of water. There may be areas of calm and areas of ripples, or chops. When that happens, reflections will be lost-and-found or broken-up. This effect is a very valuable aid to artists because it lets you decide just how much color or value you want to show anywhere in the composition.

It also allows for a mixture of reflections; in this case, choppy water allows sky color to intermingle with tree colors.

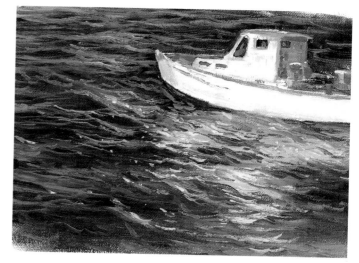

reflected color

Objects will reflect nearly the same color in smooth water — unless it is shallow, when some ground color shows through.

In choppy water, the color image may be distorted and the color itself may change.

In this illustration, the reflections are extended because of the chops, but the white boat reflections have more yellow in them. This is caused by color properties in the water that we cannot see, such as the way sunlight penetrates the water and bounces off the bottom of the ocean. It could even be caused by objects beneath the water. This is another case where you can make a choice that enhances the composition.

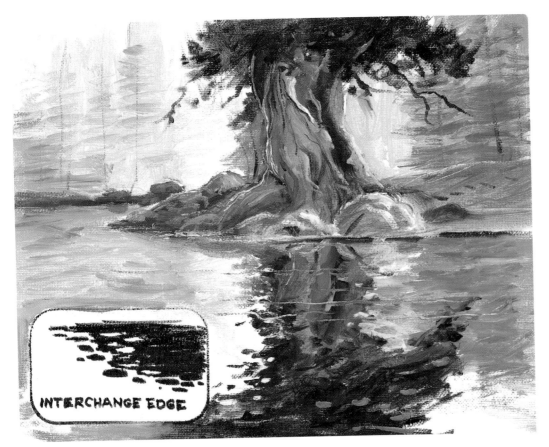

INTERCHANGE EDGE

something happens when edges interchange

The meeting of two different reflections, such as the reflections of sky and tree in this oil sketch, may interchange their colors and values along the edges. This happens particularly when the water is rippled, or choppy. Notice the dark values in the light values and the light values in the dark values. This is another result of bounced light, and is a good thing to have up your sleeve to include because it softens edges that may otherwise be too hard, and therefore command too much attention.

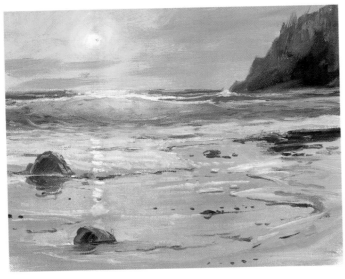

reflections and the sun's path

Have you noticed that whenever you walk up or down a beach or along a lake shore, that the path of light from the sun always comes directly to you? This is because everything you see is reflected in your eyes. All reflections come to the viewer, even if distorted for one reason or another.

Make a note to never have the light path of the sun or moon go off on a slant because that takes the viewer out of the painting.

keys to reflections

- In ripples the mirror image is distorted.
- Still water doesn't have extended reflections.
- Extend reflections viewed from above.
- Capitalise on the lost-and-found effect.
- In smooth water, objects reflect the same colors.
- In rippled water, bounced light allows dark values to be seen in light values, and light values to be seen in dark values.

"Remember that reflections always come to the viewer; they do not go off in other directions except as the image of slanted objects."

special effects

sparkle

Sometimes, water sparkles like "glittering diamonds", and writers often describe it that way. Sparkle is a special effect that you can use at any time in your paintings. It is simply caused by the reflection of the sun on the scattered edges of ripples. Even if the sun doesn't appear in the painting, or it is a wintery day like in this oil sketch, you can always introduce some sparkle. It is a valuable tool for adding interest or for breaking up a dull area.

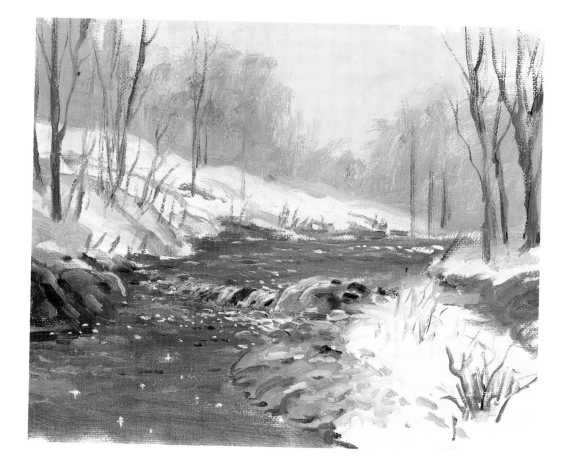

glare

Glare happens when the face of a wave, or the surface of a body of water, acts like a mirror for the sun and we get a blast of light right in the eyes. There is no way paint can duplicate the intensity of the sun; in fact, we can only achieve about 10 per cent of its intensity, but we can give the illusion of glare and it adds something to our paintings. Glare is a concentration of light rather than scattered light, and it can be used wherever needed for interest or to break up a value or a color in the composition.

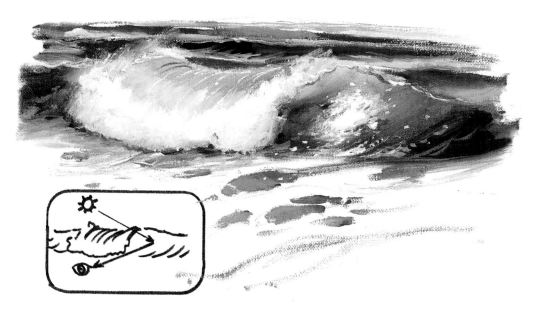

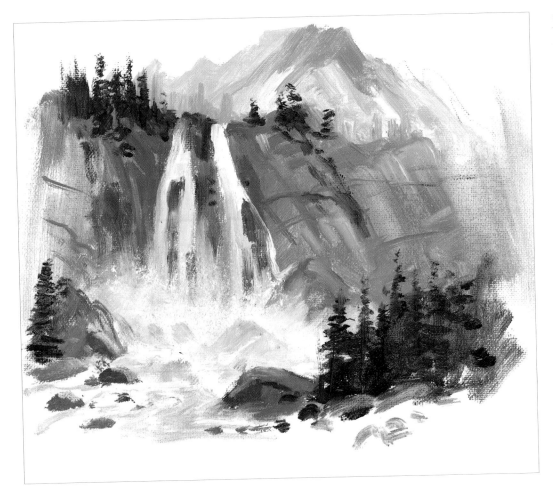

mist from falling water

Waterfalls often create mist when they strike the rocks below. This is simply aerated water and appears white, but mist can also be in shadow. Mist softens the edges of an area and contrasts nicely with hard edges nearby. It can also obscure or fade any rocks or objects that you want to be less important.

wave spray

Spray is created by wind, the crashing of a breaker, or when a wave strikes a rock. Like mist, spray is also aerated water and appears to be white. However, some of the wave's color may fade upward into the spray. The thing to remember here is that spray, or bursts of foam, have no particular shape though they may move in a particular direction. Their edges are very soft so paint them with dabs from the tip of a hazing brush rather than with deliberate brushstrokes. This type of spray is also good for fading out areas you want to make less important.

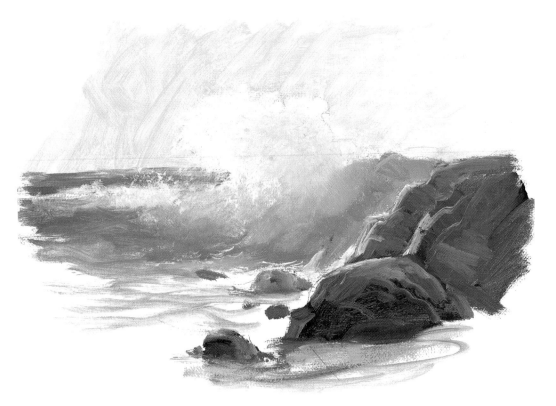

transparent and translucent water

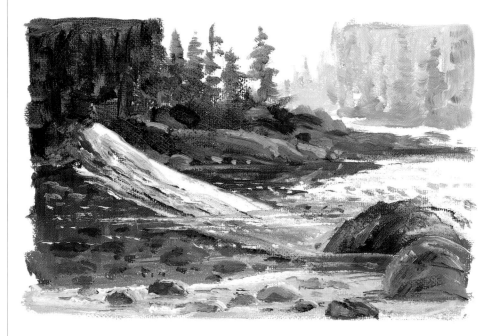

transparent water
Transparent water is water clear enough that you can see objects beneath it such as rocks or sunken logs.

translucent water
Translucent water is water that sunlight may pass through. This is a special effect visible in ocean waves. When a swell is at its height, the upper edge becomes thin enough for light to pass through it. You must be careful not to paint the whole wave translucent because in reality the lower portion of the wave is much too thick to allow passage of light.

keys to water

- Water is mainly level
- It changes shape
- It is a reflecting agent
- It is transparent
- Water is a great design aid
- Water is a great mood indicator

These are some of the properties and special effects that may be used to improve a painting that includes water. Throughout this book you will see many examples of them.

chapter 3

mood

Planning the mood of your painting is as important as any of the technical aspects. Mood is the ingredient that hooks the viewer and it will make your painting stand apart.

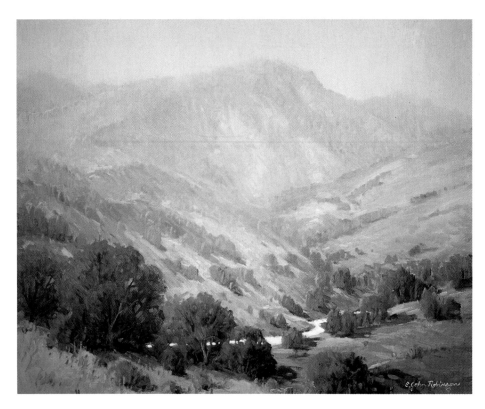

The Los Padres, oil on canvas 24 x 30" (61 x 76cm)

MOOD PLAN FOR THIS PAINTING
atmosphere and space

In this painting I attempted to give a warm feeling of space and raw nature and I balanced all that land with a distant ribbon of water. Water is the vital ingredient here and the viewer will be attracted to it.

The feeling of so much distance and space will affect each person differently. Some will feel free and unshackled, able to explore or wander without fences, or simply gaze into the distance without anything in the way. Others may feel alone, abandoned, lost, or even frightened. It's important to understand that the mood you want to convey may not be felt the same by all people. However, that should not stop you from conveying the mood you want. Remember, all moods are perceived according to the individual's background and personality.

When people look at a painting they will respond to what they SEE (a harbor, a waterfall, a house, and so on), but they will seldom put into words what they FEEL. Yet what they feel is in many ways more important than what they see.

Let's say a person particularly likes paintings of harbor scenes and they are in a gallery room with twenty versions of the same harbor scene, that person will probably gravitate to one in particular. Why? Because there was something *beyond* the actual scene that attracted them; and the magnet was the painting's MOOD.

Within all paintings, whether painted by amateurs or professionals, is mood; some moods are planned and others are unplanned. What I wish to bring out in this chapter is the knowledge that mood will be in your paintings and the artist who plans for this is far ahead of those who do not.

I strongly stress that planning a painting ahead of time is essential to success. I will further emphasize that planning, or at least being aware of the mood, is just as important as planning for color and values.

As I stated in the introduction, just about any mood or emotion a person feels can be transferred to a painting. That painting then has a life of its own and its mood will be conveyed to the viewer. Therefore, it is vitally important that you become aware of mood and USE it carefully. Just as there should only be one center of interest in a painting, there should also be just one mood. Mixing moods is just as confusing as having too many stars on stage at once.

For this chapter I have chosen finished paintings, each with a different mood, to reinforce this concept.

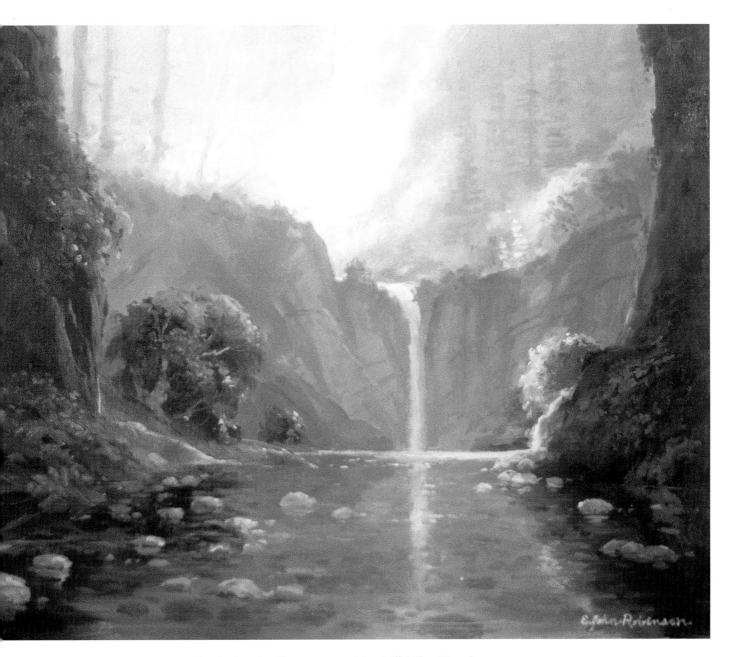

Eagle Creek, oil on canvas, 16 x 20" (41 x 51cm)

peacefulness

Here is a mood that probably appeals to most people. Even though some may feel some loneliness, most will have a sense of peace and quietude. This is nature unspoiled by the progress of civilization, a place without rushing traffic, blaring noise and crowds. It is not just the scene that carries the mood either: the colors are cool and restful with just enough warmth to balance it. Had there been too much warm color it would have been less restful. The bluffs on either side, almost like the wings of a stage, give the place a sense of being protected. Also, there is nothing to lead the eye out and beyond so this becomes a scene of here and now, a haven of rest.

Moonlight at sea, oil on canvas 24 x 30" (61 x 76cm)

MOOD PLAN FOR THIS PAINTING
aloneness

Now here is a mood that most people would not appreciate or relate to. This is cold, lonely and there is not so much as a beach or a boat on which to stand. In fact, most people would have a sinking feeling looking at this painting. However, it sold from a gallery in a town where there was a number of Navy personnel. You see, moods are very personal and a person's background and experiences determine what they relate to.

(Below)
Ghost Town, watercolor on 300# Arches, 22 x 30" (56 x 76cm)

MOOD PLAN FOR THIS PAINTING
nostalgia

Nostalgia is a mood and it is a very popular one. Antique stores, western movies and trips to historic places are favorite activities for many people. I personally believe that people who are caught up in the rush of life need contrast, just as I have been advocating in composition. There has to be a balance in life and observing nostalgia is one way to get it. In this painting the weathered buildings, the wagon, and the western architecture all point to a time gone by. To many of us it would seem to be a quieter, more laid back time and in this painting I have pictured the old town as deserted. You will notice I used some puddles as a contrast to the otherwise dry area — a vital ingredient to support the overall mood of the painting.

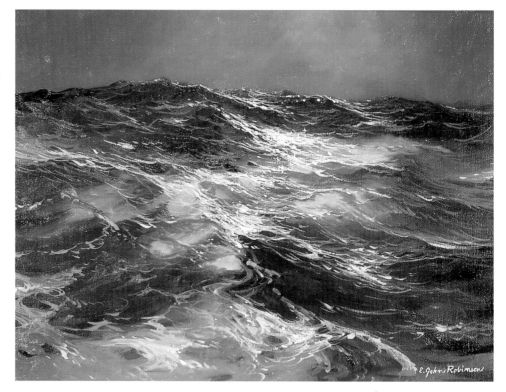

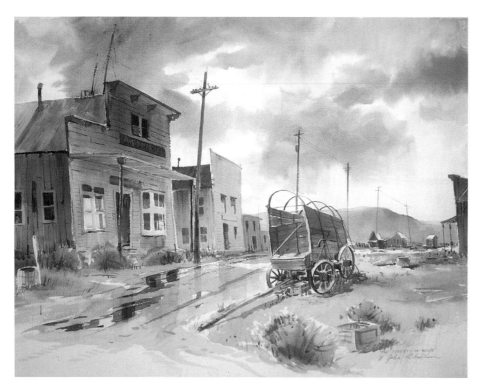

(Right) Country Road, watercolor on 300#, 22 x 28" (56 x 71cm)

MOOD PLAN FOR THIS PAINTING
winter

There is no reason not to paint a winter scene even if some people might not care for the mood. Artists must paint first to please themselves, then see if anyone responds. My experience has been that if you do your best, someone will relate to what you have done and will want to own it.

This typifies one of those drippy, winter days where objects in the distance are obscured by rain or fog and the puddles show it has rained quite a bit. However, there is a road that leads the viewer in a pretty straight line. Not too far down the road are some warm-colored shrubs and a hint of sunlight. This is a painting that says "yes, winter is here, but we are moving right through it".

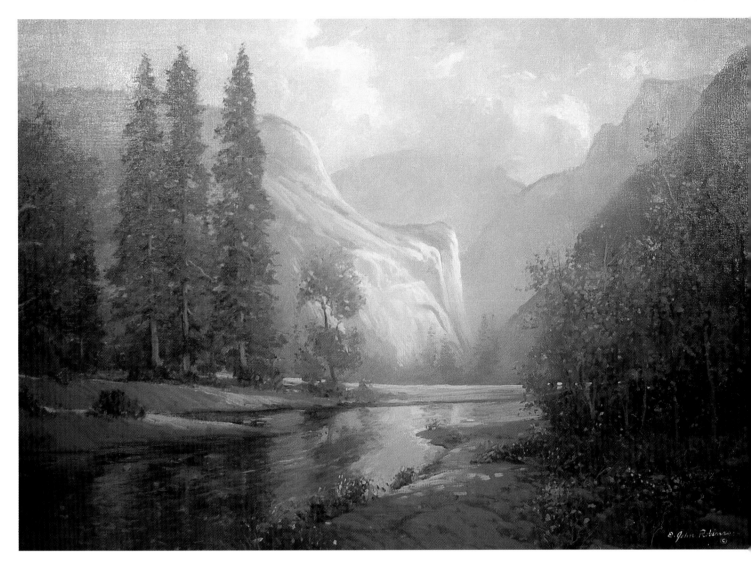

(Above) *Merced River,*
oil on canvas, 24 x 36" (61 x 91cm)

MOOD PLAN FOR THIS PAINTING

warmth and solitude

It is better to be warm and alone than cold and alone. I painted this scene of the Merced River where it flows through Yosemite National Park. I purposefully painted it using a more traditional technique to enhance the mood of timelessness. The brushwork is more refined than I generally use so it seems to look more like paintings of the past. I also chose to use warm fall colors with a little blue for contrast. The result is a mood of both warmth and solitude along with a peacefulness that only unmarred nature can give. The river reflects the trees and the granite bluffs, and invites the viewer to be reflective as well. Without water in the painting the mood of thoughtful reflection would be lost.

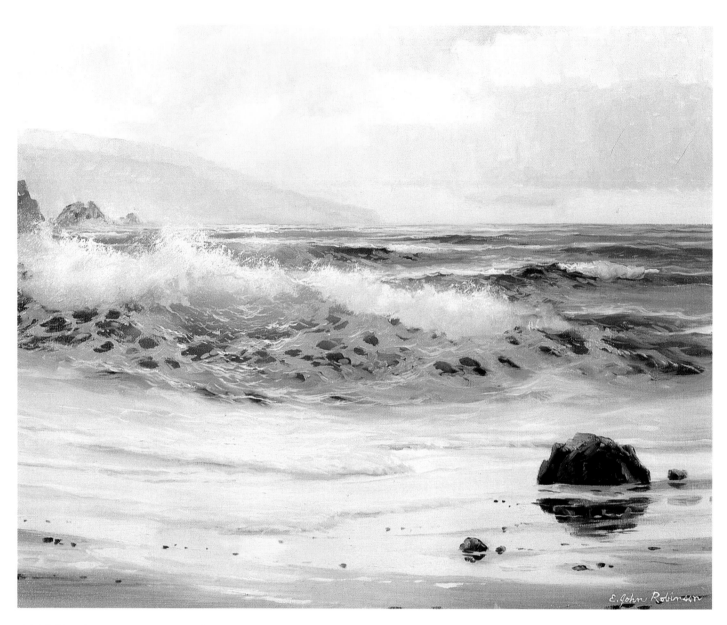

7:30 P.M., oil on canvas, 30 x 40" (76 x 102cm)

MOOD PLAN FOR THIS PAINTING

rest

All themes need a contrast: a dark painting needs some light, just as a light painting needs some dark; water paintings need some land or at least some sky, and landscapes need some water or sky. It's the same with color. A cool painting needs some warmth just as a warm painting needs some cool. This is a principle of nature: all things have an opposite. The thing to remember is, nothing in nature is truly equal. Therefore make one thing more dominant than its counterpart. For example, use more warm than cool colors, or the opposite. In this painting the cool colors are dominant because they use up more space than the warm ones. The sea takes up more space than the land or the sky.

It is a painting of warm and cool colors based on horizontal lines that suggest rest.

"Just as there should only be one center of interest in a painting, there should also be just one mood."

Sierra Falls, oil on canvas, 24 x 30" (61 x 76cm)

MOOD PLAN FOR THIS PAINTING
falls

I treated these falls almost as a mood itself. Granted, many moods may be portrayed using waterfalls, but for some reason, falling water alone suggests mood. The falls do convey motion and the water is in direct contrast to the unmoving land around. The waterfall also makes a wonderful sound as it strikes the rocks or the pool below and there are often rainbows (another popular mood) dancing in the spray. I suspect also that a waterfall represents some inner feeling that a person can fall and then go merrily on their way without harm. Life is very much like moving water. It is a journey full of motion and energy. I have noticed that when water meets an unmoving rock it doesn't try to batter it to one side, it merely flows around and continues its journey. Hmmmm!

Sunny Morning, oil on canvas, 24 x 30" (61 x 76cm)

suggesting the new day

This could be early sunlight on the west coast and late sunlight on the east coast. In either case the sun at those positions carries a warmer color than at mid-day. I painted it as a morning scene. The viewer stands in shadow near a very heavy surf, but looks to the distant warm light that will soon bathe the scene. There has been a storm and both the sky and the sea show a lot of movement. The mood then, is one of high energy with the promise of a fine, new day. The sky is clearing and the sunlight is bringing warmth.

The storm has passed. I think you can see that this mood will bring comfort to someone who has experienced some rough times but looks forward to better days ahead.

keys to mood
- Plan for mood.
- Develop only one mood in each painting.
- The mood you intend may not be the mood accepted by the viewer. That's okay.
- Mood comes through handling of values, color and light.
- Handle distance carefully.
- Look for lead-ins.
- Exploit movement and calm to enhance the mood.

Storm's Aftermath, oil on canvas, 30 x 40" (76 x 102cm)

MOOD PLAN FOR THIS PAINTING
motion and energy

This painting is somewhat like the previous one because it has to do with a storm. The difference though, is that this storm is still going on. There is a hint of sunlight, but it is weak. The majority of the composition is devoted to the high energy movement in the surf.

Some people would feel overwhelmed by this mood but others would be energized. It is a painting of strong, swirling motion and vitality, and calmness is a long way off.

In conclusion, let me repeat that mood is just as important as color, line and value. There are limitless moods that humans experience and they can be transferred to any painting. It is therefore important that we understand different moods and make an effort to put them in our paintings. The following chapters will give ways to do just that, and your journey through them should be rewarding.

wet ground

Wet ground is a valuable tool in your design armoury — and it's lots of fun to paint too.

Another way to use water in your compositions is to simply show wet ground. This can take the form of wet streets and roads, rocks, fields or wet sand. Even shallow creeks and rivers are little more than wet ground.

Wet ground gives you unlimited ways to reflect colors, values and objects without the characteristics of moving water. Water on the ground is usually very shallow and placid. Often, you can see the color of the ground beneath the water, and this can obscure any other reflection. You choose where to place wet ground and then decide how much you want to reflect.

Wet ground also sets mood: it can mean rain and fresh air, or it can be a nuisance. When linked with soggy skies the mood can be depressing. Wet ground can mean a farmer is irrigating his fields or that someone left the garden hose on. Mood is created by you, and the way you use water will reflect whatever mood you choose.

Utah Canyon, **oil sketch on canvas,**
12 x 16" (31 x 41cm)

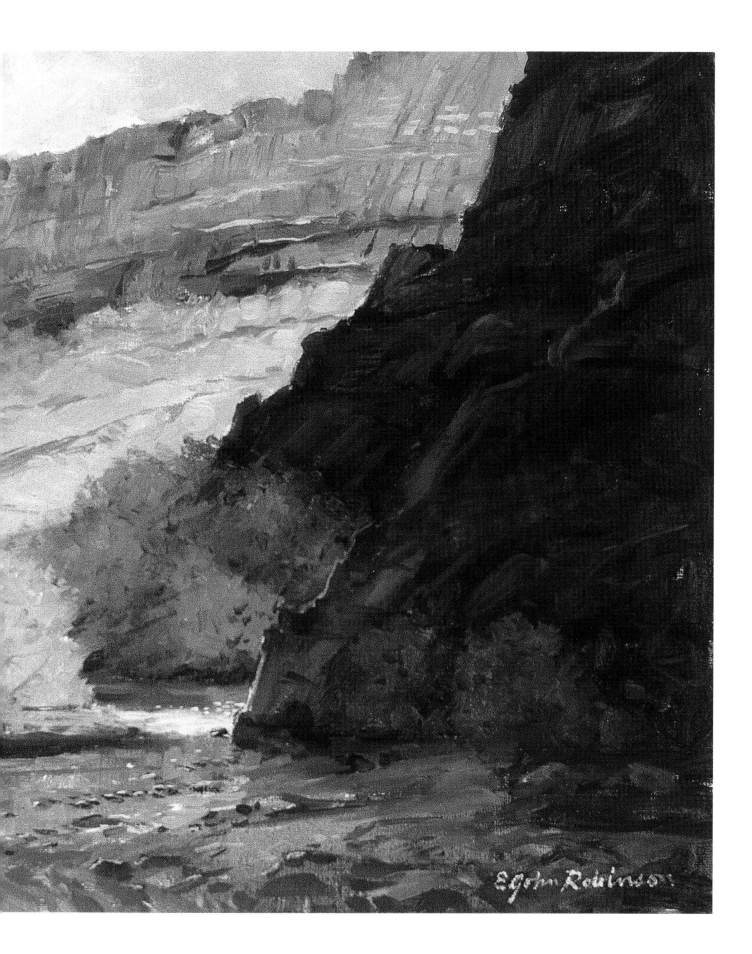

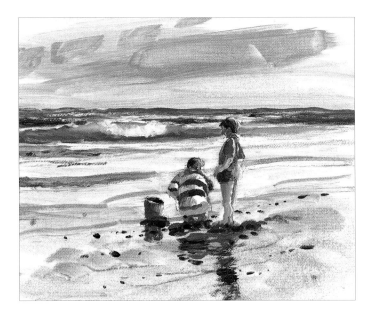 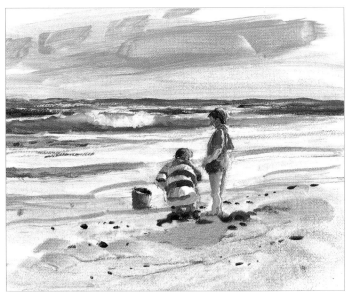

ACTION PLAN FOR SKETCH

connecting figures with wet sand reflections — watercolor

The standing figure connects to its reflection creating a nice vertical line which is needed to balance the otherwise all horizontal composition. Notice also that the waves are far enough away to be non-threatening. Let us not mix moods!

here's how it would look without the reflections

Here's the sketch without the reflections of the children suggesting they were playing on dry sand. The arrangement of the figures is stair-stepped from the pail upward to the standing child. Not a bad arrangement, but compare it with the version that has reflections and you will see how much better that one is.

"Keep in mind that the thinner the sheet of water, the more ground color will show and there will be less reflections from other sources."

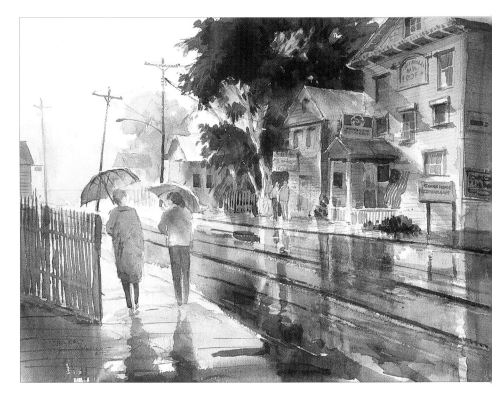

Rain in New Hampshire, watercolor, 12 x 16" (31 x 41cm)

ACTION PLAN FOR SKETCH
reflecting lights into wet streets — oil

Some artists have built wonderful careers by painting scenes showing wet streets. The color of the pavement and reflections of buildings and objects may show to a certain extent, but what shows best are lights, even in the daytime. They may be lights from vehicles, colorful signs, lit up windows, or the sun or the moon. In any case, wet streets make a fascinating subject and there are unlimited possibilities.

ACTION PLAN FOR SKETCH
reflecting wet pavers — pastel

Wet pavers give off very subtle reflections. There cannot be a mirror image because of the cracks and textures, but the color of the pavers shows more strongly than the reflections of other objects. Keep in mind, that the thinner the sheet of water, the more the ground color will show and there will be less reflections from other sources.

**ACTION PLAN
FOR SKETCH**

**reflecting sunlight
from wet sand —
watercolor**

Here the wet sand reflects the rocks and the colors of the sky.

**here's how it would look
without wet sand**
Without wet sand the composition would be divided between a light background and a dark foreground. Showing pebbles and small rocks is essential to giving the illusion of very shallow water.

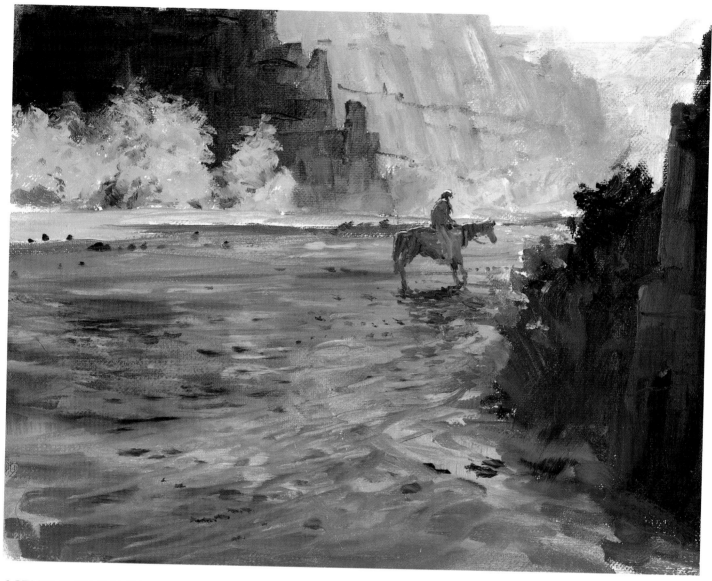

ACTION PLAN FOR SKETCH

using shallow water to reflect canyon colors — oil

As I mentioned before, even creeks and streams are shallow enough to be little more than wet ground. This sketch is from Canyon de Chelley in Arizona, which is owned by the Navajo Indians. The canyon floor is very flat and nearly level, so the stream spreads out thinly. The water is so shallow in places that you would hardly get your feet wet walking through it.

The canyon walls are a combination of beautiful sand colors, from pale blues to mauves and rusts, and they all reflect in the wet ground. In cases like this the water may reflect colors out of the picture frame, thus giving even more beauty to the composition.

keys to wet ground

- Wet ground sets mood.
- Wet ground is a great composition aid.
- You can choose what you want to reflect.
- Wet ground allows you to reflect color, values and objects.
- Wet ground is thin and placid.
- The ground color often shows through and obscures reflections.
- Wet rocks are like wet ground and reflect what is above or around them.

chapter 5

puddles

When your composition is down and out, reach for a puddle!

I grew up in the country where most roads were unpaved, and puddles and ruts were as common as farm fences and freeranging chickens. The folks driving their cars didn't care for puddles, but as a child I found much delight splashing my way home from school or sailing matchbox boats on these mini-lakes. I found that every puddle was different and if I looked closely at them, each had some unique characteristic. That is a concept all artists learn; observation leads to in-depth knowledge. Whether you paint trees, waves, waterfalls, or anything else in nature, they all have individual characteristics, just as people do, and that is what makes them interesting.

Puddles may seem insignificant in regard to a painting, but the truth is they are a very valuable aid. Puddles can be a center of interest or they can be used to help balance the composition. There always seems to be a need to repeat a color or a value somewhere in the painting and a puddle, whether on a road or just on the ground somewhere, is the perfect way to do it. As with any form of water, puddles reflect what is above and around them but a puddle can be placed where it is needed in a composition, unlike larger bodies of water. Besides these uses, puddles also bring the element of water to a painting, which makes it more natural and authentic.

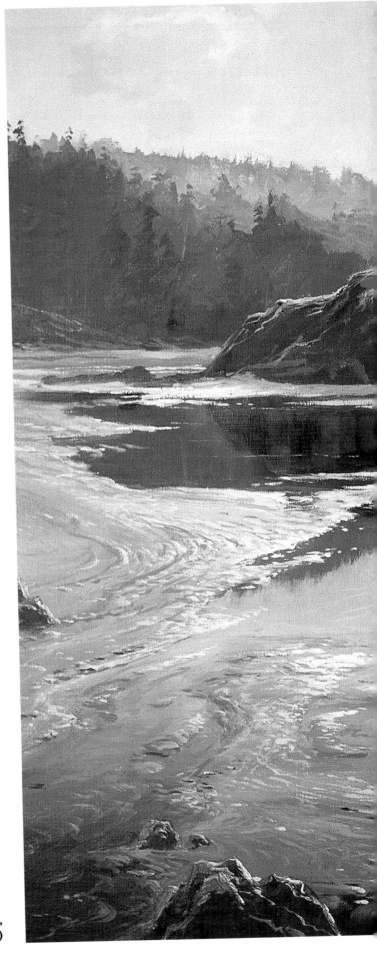

Tide Pools, oil,
30 x 40" (76 x 102cm)

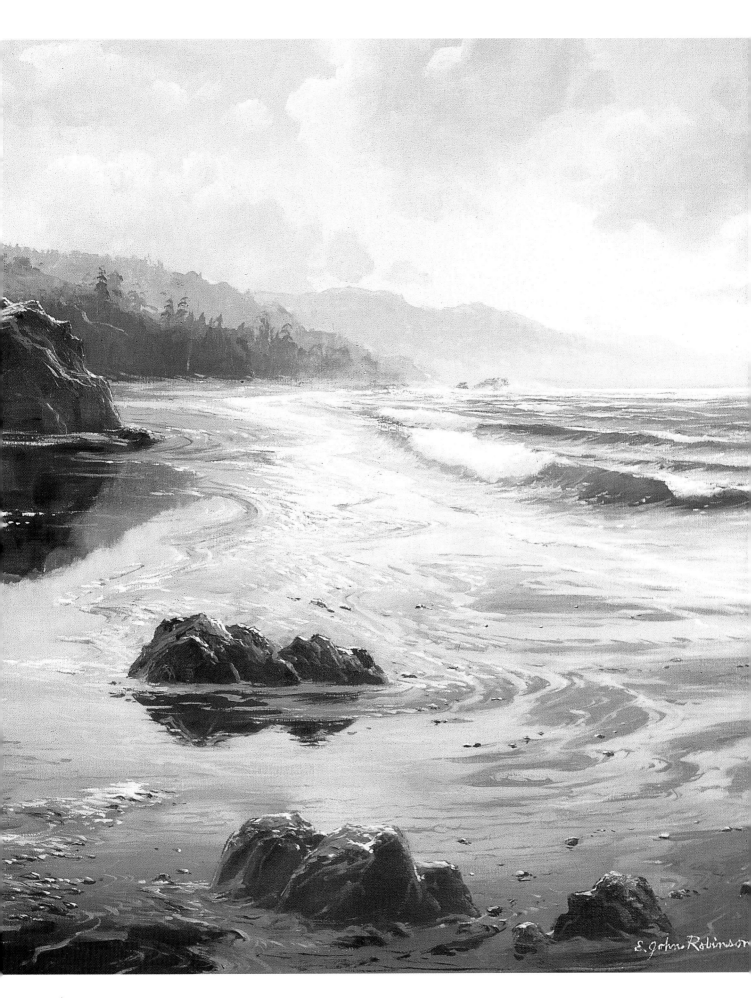

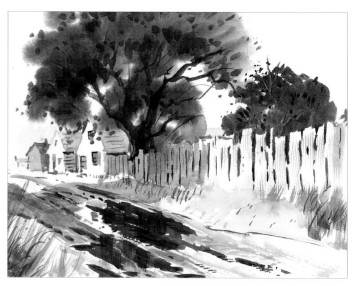

ACTION PLAN FOR SKETCH

introducing light into dark with a light puddle — watercolor

When a composition needs a repeat of a value, either light or dark, a puddle will do the job. In this sketch the light puddle repeats the light value of the sky and brings a better balance to the composition. Try to see the scene as a dark road and with no puddle and you will notice that there would be too many dark values.

ACTION PLAN FOR SKETCH

introducing dark into light with a dark puddle — watercolor

This composition needed a strong dark in the foreground to balance the dark of the two trees behind the fence. The puddle not only made it possible to add another value, but it also made the road more interesting than if it had just been a dry, straight dirt road. Notice that light puddles need a dark background and dark puddles a light one.

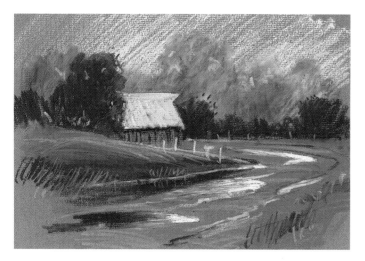

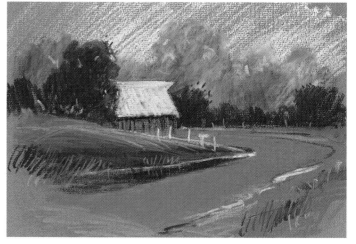

ACTION PLAN FOR SKETCH

using light and dark puddles to lead the eye — pastel

The road in this sketch should lead the eye to the barn, but the value is so neutral that it doesn't do a very good job of it. Adding a series of puddles captures the eye and leads it down and around to the center of interest. These puddles are both light and dark ones and repeat background colors as well as values.

here's what it would look like without the puddles

"Notice that light puddles need a dark background and dark puddles a light one."

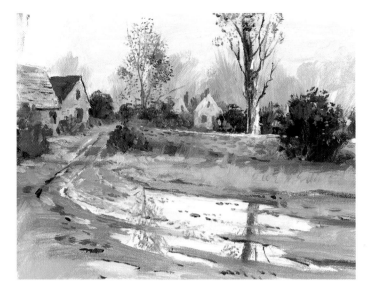

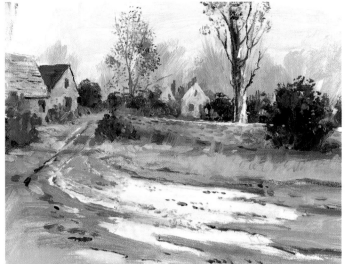

ACTION PLAN FOR SKETCH

using puddles to reflect vertical lines in the design — watercolor

There are times when puddles are necessary to repeat colors and values but there are also times when lines may need repeating. In this sketch, the puddle allowed me to place a vertical line (the tree trunk) in the foreground. Without this, the composition would be less interesting and out of balance.

here's what it would look like without the tree trunk reflection

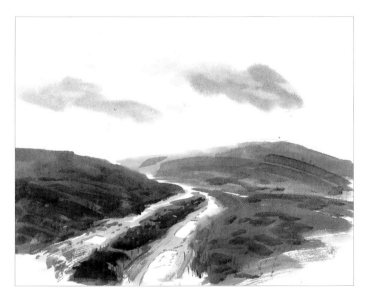

ACTION PLAN FOR SKETCH

using puddles to balance sky and ground values in a moody scene — watercolor

I was struck by the starkness of this moor scene in England. Moors are lonely places. A rutted road shows movement and direction, suggesting there is somewhere else to go. The puddles in the ruts reflect the light sky and break up the dark foreground values into more interesting shapes. This is another example of using puddles as lines as well as for repeating values.

"Just remember, puddles, no matter what their shape, should always appear to be level."

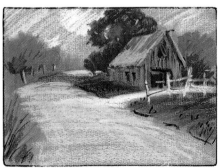

a dull composition . . .
In this sketch there are no puddles and the road is broad and rather uninteresting. The road also takes too much area in the composition.

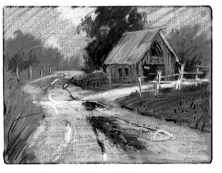

. . . revived with puddles
Here's how puddles improved the composition. First, the road is broken up and becomes more interesting. Second, the dark value of the background tree is repeated in the foreground puddle, and the composition is better balanced.

ACTION PLAN FOR SKETCH

using water as contrast — watercolor

the actual dry scene ...
Bodie, California is a wonderful ghost town that is preserved in its natural decay by the state.

I had just painted this scene on the spot on a hot August day when a thunderstorm loomed toward the town. I had already painted a wonderfully wet, drippy sky but otherwise the scene was as dry as the old, weathered buildings. It made me thirsty just standing there. See opposite for how I transformed this scene with a few puddles.

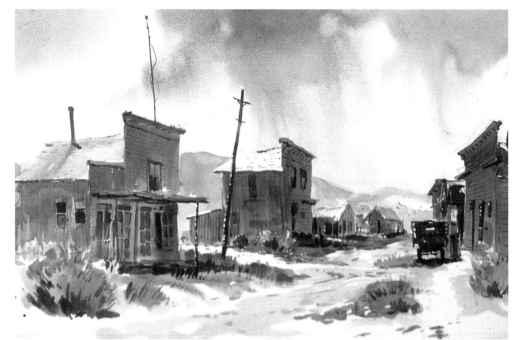

ACTION PLAN FOR SKETCH

using puddles to reflect color and value — oil

I show this sketch because it is an example of using puddles in another way. The main purpose is to repeat both color and values and this is accomplished. Notice also the shapes of the puddles. You can choose whatever shape you want for puddles as long as they make good sense. Again, you decide exactly how much you want and just where you want them. Just remember, puddles, no matter what their shape, should always appear to be level.

ACTION PLAN FOR SKETCH

introducing a tide pool puddle for balance — oil

Tide pools are puddles of water left from high tides or rains and they can be used like any other puddle: to reflect what is above and around them. In this sketch I used the pools to repeat the colors of the sky and the rocks onto the sand. If I had not done this, the dark sand would be uninteresting and would take up a lot of space without doing anything to balance the composition.

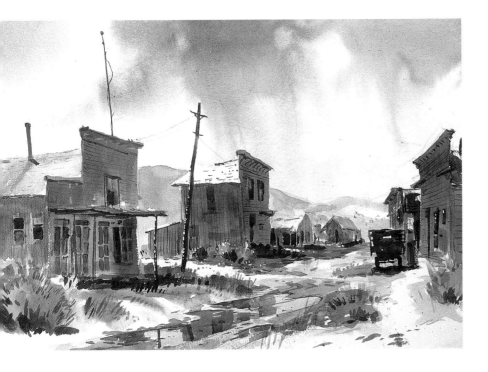

... revived with some puddles

The storm thundered its way past while I sheltered under a porch. The desert air was alive with energy. It was a brief rain, but a hard one and the rusty tin roofs funneled the rain onto the street. When the rain stopped I stepped out and saw the puddles. I immediately set up my painting and added just what the composition needed. The puddles were a contrast to the dryness of the scene and gave a sense of freshness. They also gave me a chance to repeat some color, values and the line of the pole. I'll admit it would have been just fine to leave the painting without the puddles; a dry, deserted ghost town is a mood in itself, but I wanted the element of water as contrast, and that is what I did. It is a slightly different mood but it was my choice.

I called this "The streets of Bodie", watercolor, 15 x 22" (38 x 56cm).

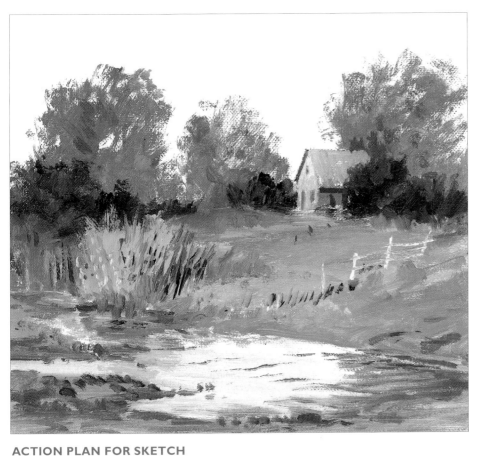

keys to puddles

- Puddles can solve many design problems — particularly balance.
- You can lead the viewer's eye with puddles.
- Puddles allow you to repeat colors.
- You can introduce dark into light and light into dark.
- Puddles are useful because they reflect what is above and out of the frame.
- You can invent puddles to suggest wet ground — and you don't have to have hard surfaces to do it.
- Puddles enhance mood.

ACTION PLAN FOR SKETCH

using a rainwater puddle to add interest — oil

All puddles do not have to lie on a road. In fact, they can be used anywhere in a landscape where they are needed. If you need an excuse for one, remember that the ground is uneven and so hollows and depressions will fill up with rainwater.

chapter 6

creeks

Creeks offer you a terrific way to give
variety to your compositions.

Creeks have their own special place in the landscape.
Although their moods may vary like anything else,
they are neither placid, like soggy ground, nor large and
imposing like rivers. You can use a creek to enhance any
landscape. Simply introduce the element of water and
then add to or create the mood you want to suggest. For
example: If you set out to paint a woodland scene and you
want it to be dark and mysterious, then a creek with deep
reflections can increase that mood. To add to the mystery,
it would be even better to compose the creek so that the
viewer cannot see where it came from or where it is going.
There are endless possibilities when subject and mood are
combined.

Valley Stream, oil, 18 x 24" (46 x 61cm)

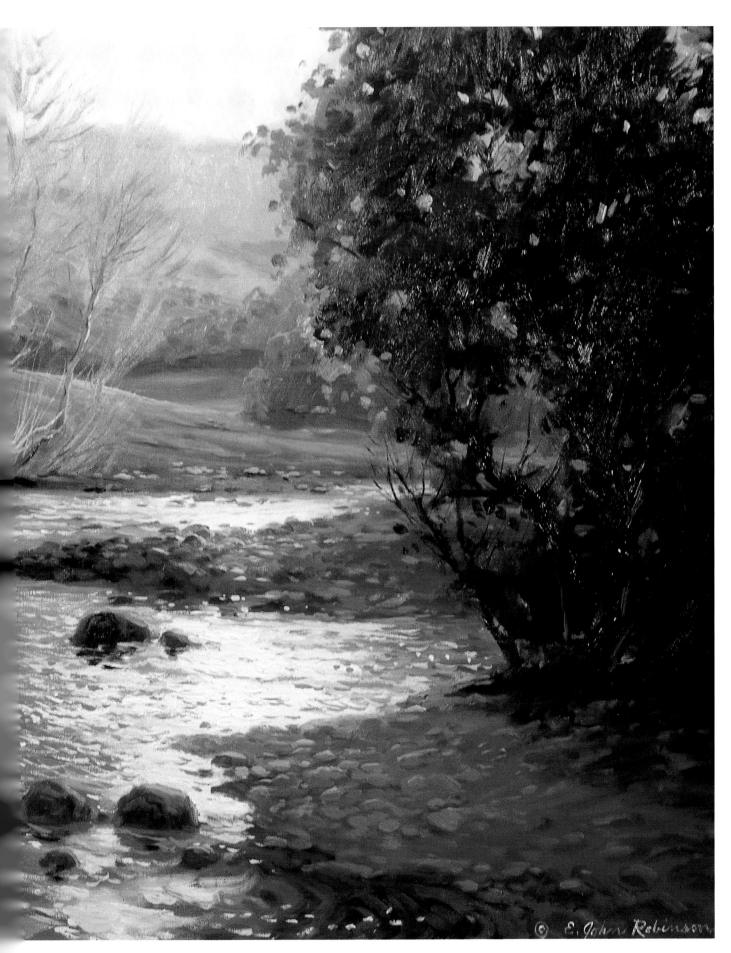

© E. John Robinson

the S-curve

Nearly all of the old "how-to" books on art emphasized the need to use the S-curve in compositions. These books pointed out how the quiet, meandering line of a creek or a road was tranquil, made the painting "pleasant" to view and led the eye through the composition. This is a good concept, but very limited because it is only one of many moods you might want to convey. Nevertheless, let us start with the old "S" composition and then move on from there.

positive curve
There are at least two ways to show the S-curve: Here the creek is a definite, or "positive" outline of a flattened "S" and is reflecting some vertical lines.

implied curve
Here the slightly curved road is nowhere near an S-shape, but the puddles form one in a broken line. This is more subtle because the line is "implied" but still conveys the same meaning.

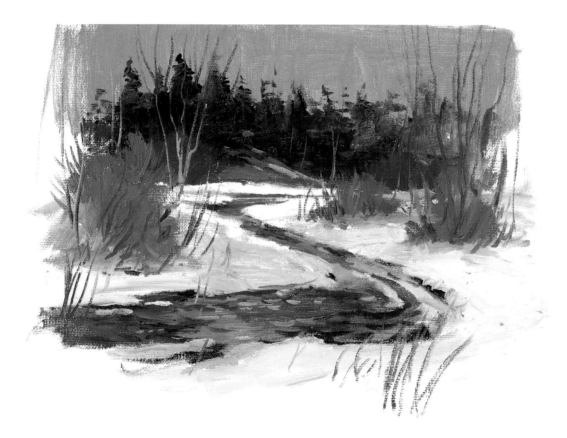

slow S-curve, no reflections — oil sketch
WEAK
Notice in this illustration that not only the creek, but the banks on either side form a flattened "S". For the most part, the creek only reflects the sky and is therefore a rather dark line. It is less interesting because it has no variation to speak of. This approach would work well if there were a definite center of interest, but the whole creek draws the attention. There needs to be only one focal point.

slow S-curve with reflections — oil sketch

BETTER

This is nearly the same composition, but in this case the dark background reflects only a part of the creek. Doing this breaks up the monotony of the sky reflection. In addition, having some white sparkle where the dark meets the light creates a focal point. In the previous example, the creek was the subject, but it has little interest. In this case the creek is not as much the center of interest, but it reflects the mood and allows for the sparkle that draws the eye.

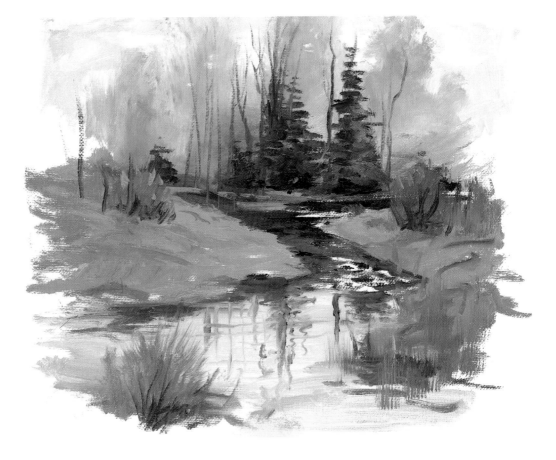

modified S-curve — oil sketch

OUTSTANDING!

This creek is meandering but the "S" is hardly visible. Nevertheless, it still leads the eye and adds quiet charm to the composition. Notice the variations in the creek. It meanders out of distant light toward the viewer, then has to scurry over some rocks, back into light, then spreads out to a slower pace. There is very little reflective quality of objects. Mostly the water is reflecting light, atmosphere and shadow. Compare the variety this creek gives to the two previous illustrations.

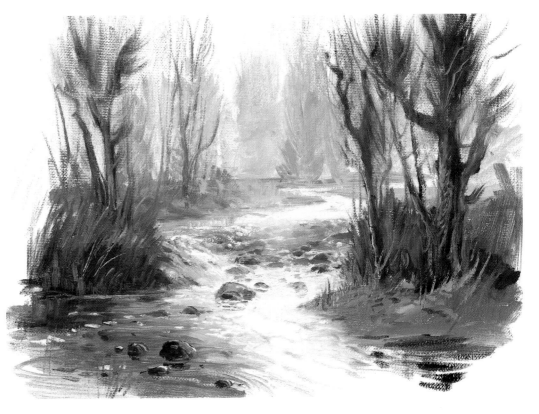

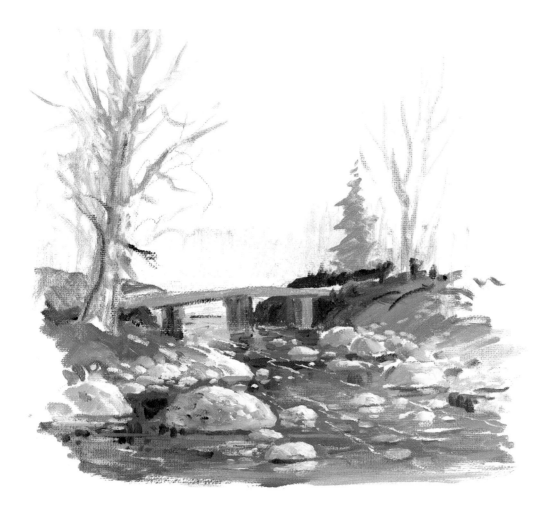

shallow water with boulders — oil sketch
By now you can see that the S-curve is no longer just the creek. In this case the line of the bridge converges with the bank that leads to the creek and creates the "S". This illustration also shows how water can look brown because it is shallow. Only the boulders reflect a bit.

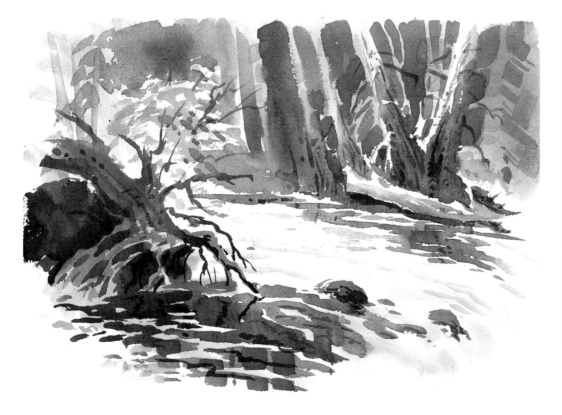

woodland-creek with motion — watercolor sketch
The thing to notice here is that the only reflections are in the still water eddy in the foreground. The creek is too frothy from its rapid movement to reflect anything but light. You may also notice that the mood has changed from the previous illustrations. In this example, the viewer is a spectator watching the creek moving swiftly by. We cannot see where it came from or where it is going, but it adds to the dark mystery of the forest. No S-curve here. This is not a relaxing, tranquil mood, but is still a mood and is well worth using.

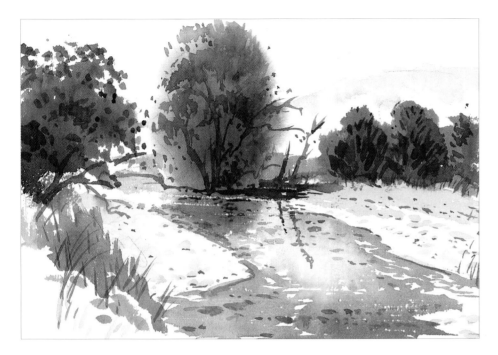

shallow creek with all reflections — watercolor sketch
This example shows the creek with several reflections: It shows the soft reflection of the central tree, the linear reflections of the snags beside it, the color reflections of the sky, some sparkle of light, and another element; the brown color of the ground beneath the water. Ground color can only be seen with shallow water and mostly prevents the water from reflecting anything else. This is another way of giving variety to the water element in your compositions.

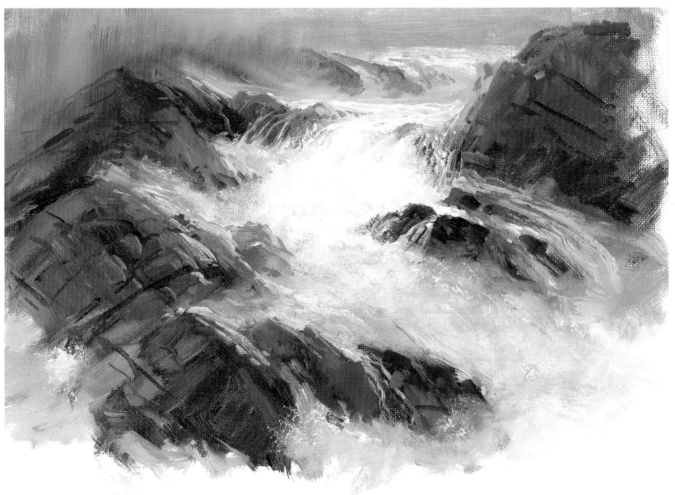

white-water creek — oil sketch
Creeks among huge rocks and moving downhill can be very rapid and frothy. Not quite waterfalls, but certainly a long way from tranquil, they become white-water cascades. They reflect only light and shadow and show very little color of their own. Here is a case where a center of interest in the creek can only be shown by having everything but the focal point in shadow. Otherwise, there would be too much white water for the eye to find any rest.

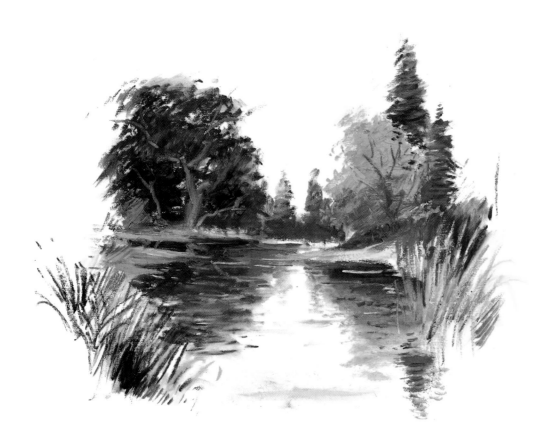

**deep water with
color reflections —
pastel sketch**
Deep water that is not moving
quickly becomes a mirror for
objects around it. Not only will
it reflect values: light, dark, and
medium tones, but it will also
reflect color. These reflections
though, are not a perfect mirror
image. In most cases both the
values and the colors will
appear lighter in the reflections
than on the objects. This is due
in part to atmosphere, but may
also be due to the depth of
the water or some of the
creek bed beneath. Breaking
the reflections with some
shimmering light will take away
from the perfect mirror effect;
it also adds interest and breaks
up flat areas of color or value.

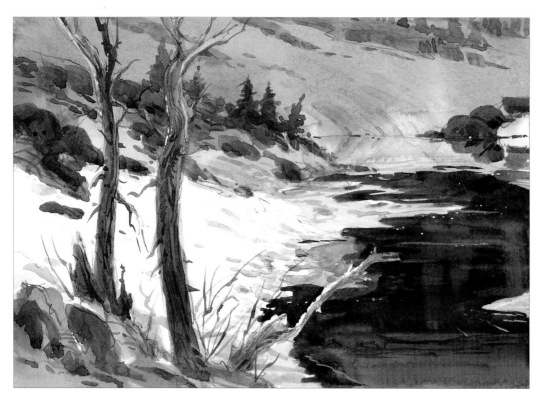

**depth with darkness —
watercolor sketch**
"Still water lies deep", is an old
saying referring, I suppose, to
those who have little to say but
may have deeper thoughts.
This can also be the case in a
painting. Here, a deep creek
that barely moves is set by a
snowy hillside. Reflections
hardly exist at all, but one feels
compelled to stare into the
depths and wonder. It is a cold
mood, but one of mystery as
well. This composition will
encourage the viewer to
contemplate.

broken reflections — watercolor sketch

Here, the slowly moving creek is broken into patterns. In the center there is a rocky sand bar that the creek flows around. Below that the creek reflects the dry grass of the hillside, but the reflection is broken by glimpses of the bed beneath the water. The other areas of the creek reflect nearby rocks, the sky, and background. These areas are broken by ripples of movement. Again, I cannot say enough about variety. Interest is added by breaking up the reflecting surface and boredom is avoided.

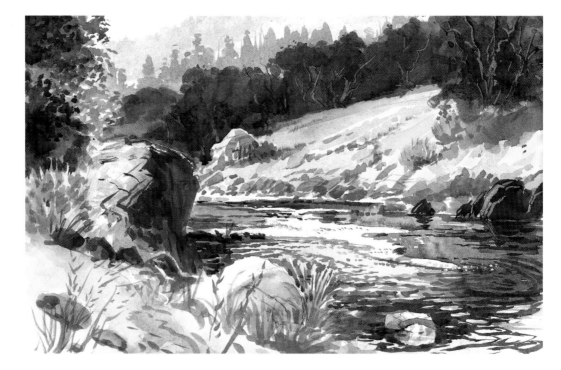

reflections only — watercolor sketch

Who is to say we have to show the objects being reflected in water? Calm water will reflect whatever is above or around it but, it is not necessary to show the objects. In this example, the eye level is placed so high that the background cannot be seen. However, the reflections tell the viewer that the background is made up of a forest of tall trees. They appear to be blurred because of the movement of the water and the atmosphere. I achieved this effect by wetting the paper and painting in the trees while the paper was still wet so the edges softened and gave the appearance of blurriness.

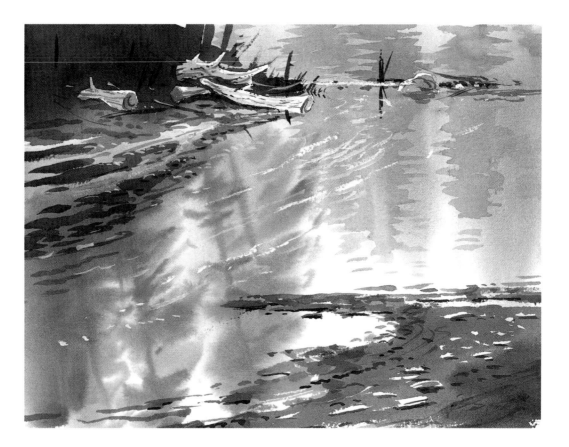

art in the making **suggesting mood with reflections and color — in oils**

Before you begin this exercise, please read all the captions so you not only know the order of progression, but why we are doing the things we do.

mood

Twilight. The setting sun signals the time when we put down our tools, or whatever job we have been doing, and settle down to rest. It is a quiet time, a time of tranquility where we perhaps reflect on the day. In this composition it is also autumn. The leaves are falling and branches are becoming bare. This is the beginning of rest for the earth. The two themes work in harmony and the creek will add reflective qualities that enhance this mood.

We will be working with a shallow creek that moves slowly. It is broken up a bit by a few boulders but reflects the rocks and bed underwater, as well as the colors of the trees and sky.

colors

In keeping with the mood, we will avoid harsh colors and tint most of them with some white.

what you will need

oil palette

BURNT SIENNA	CADMIUM YELLOW LIGHT	CADMIUM YELLOW DEEP	ALIZARIN CRIMSON

CERULEAN BLUE	ULTRAMARINE BLUE	SAP GREEN	TITANIUM WHITE

brushes
2" flat bristle brush
#1, #2, #3 and #8 bristle brushes

thinner

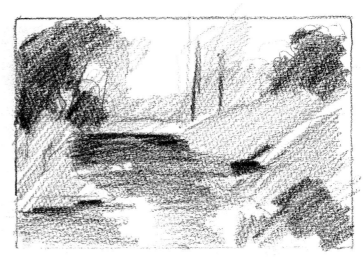

the value sketch
Here is your tonal plan for the painting. Notice where the dark darks and lightest lights are.

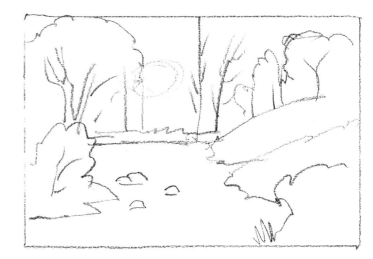

the outline

50

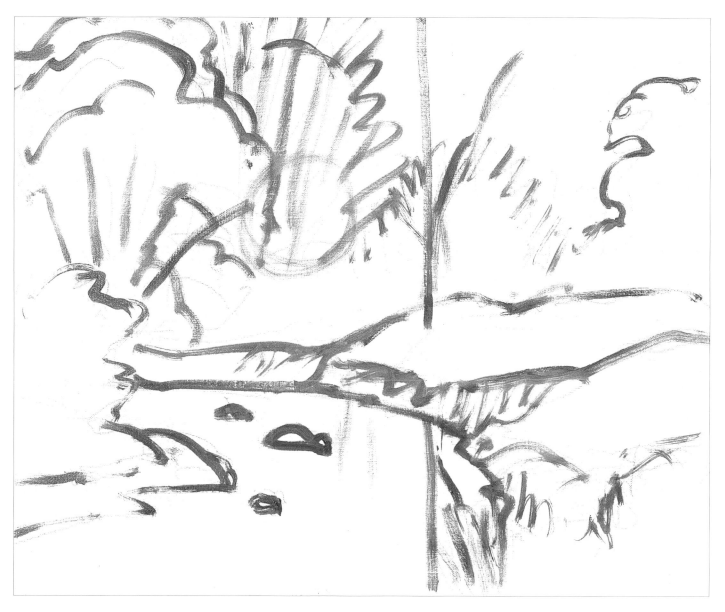

step 1: brush in the design plan
Roughly draw the outlines of the trees, the shape of the
creek and a circle to indicate the area of the sun. Use a #2
bristle brush and thinned Burnt Sienna.

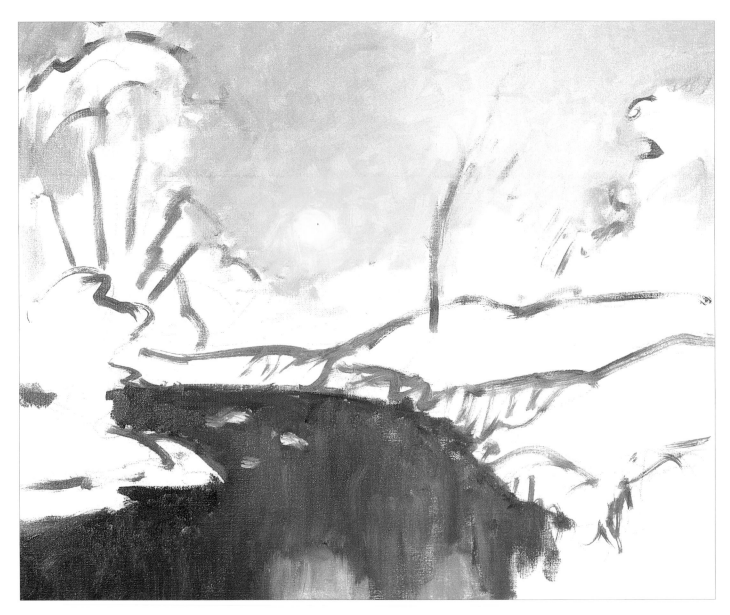

step 2: introduce the sky and creek bed

Using a #8 bristle brush, begin painting in the sky area with a small circle of pure white for the sun. Then add a mixture of both Cadmium Yellow Light and Cadmium Yellow Deep to make a peachy color and surround the white. Next, add a touch of Alizarin Crimson to the same mixture making it an even more peachy color and work it outward in all directions from the sun. As you work further out, use less yellow and begin adding a bit of Cerulean Blue, still blending with white. Finally, at the outer edges, add a bit of Ultramarine Blue.

Then go back over the sky with a dry, 2" flat bristle and blend any hard edges until the effect is a very gradual change from pure white to blue, with warm colors becoming cooler in between.

Next, move to the creek bed and scrub in Burnt Sienna as an underpaint. Add a bit of Sap Green for the darker areas and bring down some sky color where it might be reflected. Notice, I indicated where some above-water boulders would go.

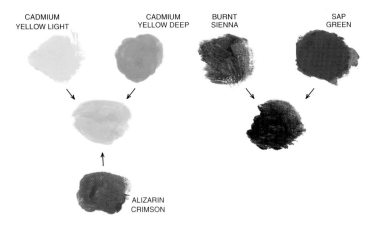

CADMIUM YELLOW LIGHT CADMIUM YELLOW DEEP BURNT SIENNA SAP GREEN

ALIZARIN CRIMSON

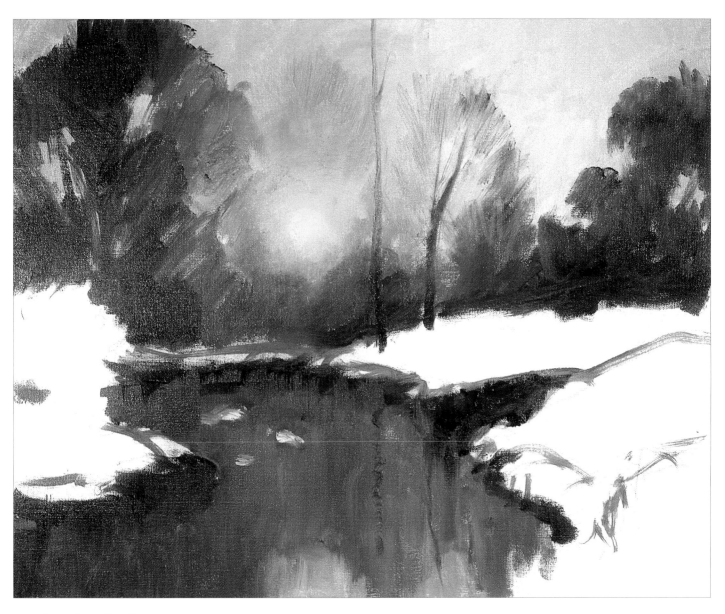

step 3: underpaint the trees

Still using the #8 bristle brush and very little thinner, underpaint the darker trees with a mixture of Alizarin Crimson and Sap Green.

This mix should have no white in it at all or it will lose its richness as a dark color. You can make it warm by adding more red, or you can make it cool by adding more green. For the trees near the sun, use less green and add white so they appear to have a reddish glow. Closest of all to the sun use mostly Cadmium Yellow Deep and white and blend it right into the wet paint of the sky. Then soften it even more with the dry bristle blending brush. The overall effect is of trees being blurred by the strength of the sunlight.

In the creekbed, use the red-green mixture and add some dark reflections. Also add two thin tree trunks and their reflections using the same red-green.

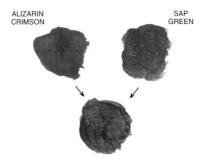

ALIZARIN CRIMSON

SAP GREEN

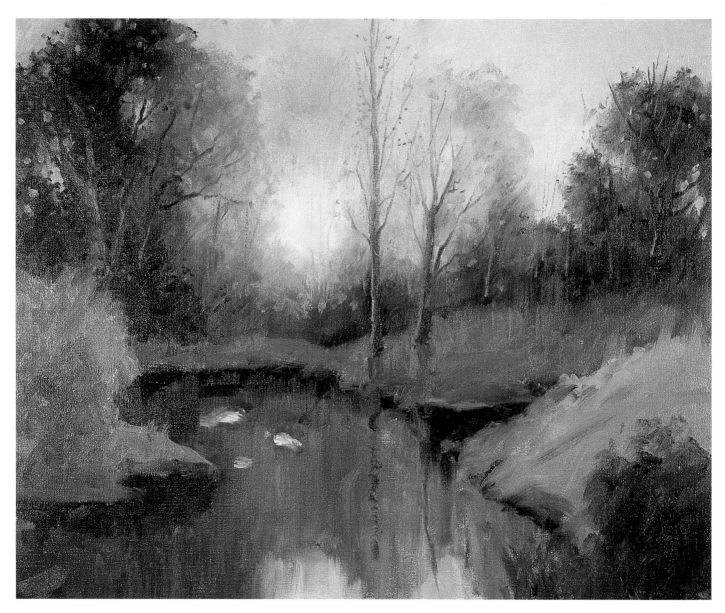

step 4: add ground color and shrubs

The #8 brush still works fine for the underpainting so continue with
it. Remember, you can make details with small brushes later. We want
the ground to be covered with a soft grass. This should be green but
yellowed from the influence of the sky. I suggest Sap Green and
Cadmium Yellow Light. Scrub in the background grass with a little
white added to the mix but used more white and more yellow for
the foreground. The underpaint for the shrubs is also Sap Green and
Cadmium Yellow but add some Burnt Sienna for a more earth tone.

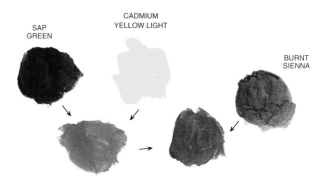

SAP
GREEN

CADMIUM
YELLOW LIGHT

BURNT
SIENNA

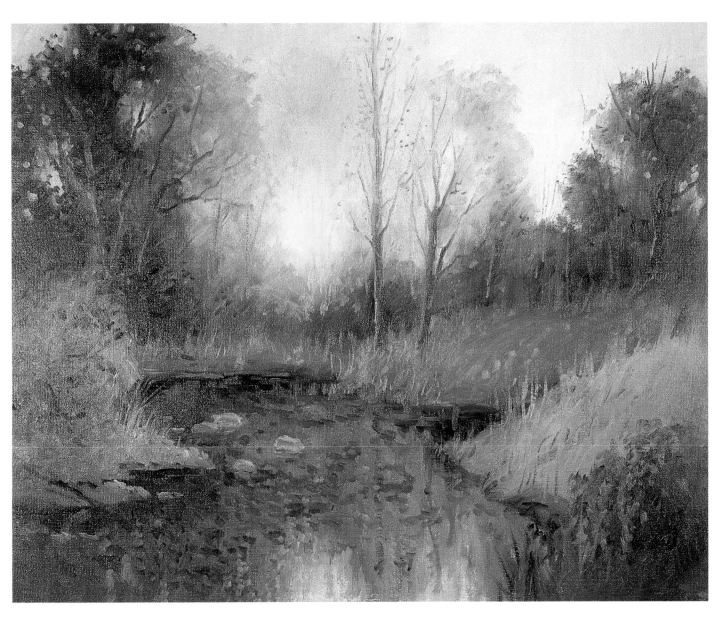

step 5: finish with the details

For detailing you could use #3, 1 and 2 bristle brushes but also some smaller round sables or synthetics as well.

In order to retain the glow and blurred effect the sun has on the trees, it is important to add colors that are only slightly darker than the background. If you make it too dark the effect will be lost.

The farther away from the sun you get, the darker the details may be. It is also important to remember to use the same colors as the immediate background, but slightly darker when detailing over the area of sun. Dot in some leaves and make some thin vertical lines for tree trunks.

For the dark trees on each side, dot in some leaves of the same color as the underpaint, but this time slightly lighter. They are away from the glow area but the sun itself may reflect off some of the leaves. Also add more red to the leaves over the redder background. For the larger tree trunks I suggest Alizarin Crimson and Sap Green, but highlighted with Cadmium Yellow Deep. The tree foliage will be too dark and too flat if you do not add some dots of sky color here and there. I called the finished painting: "Twilight", oil on linen canvas, 16 x 20" (41 x 51cm).

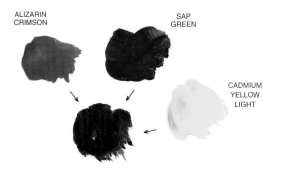

ALIZARIN CRIMSON

SAP GREEN

CADMIUM YELLOW LIGHT

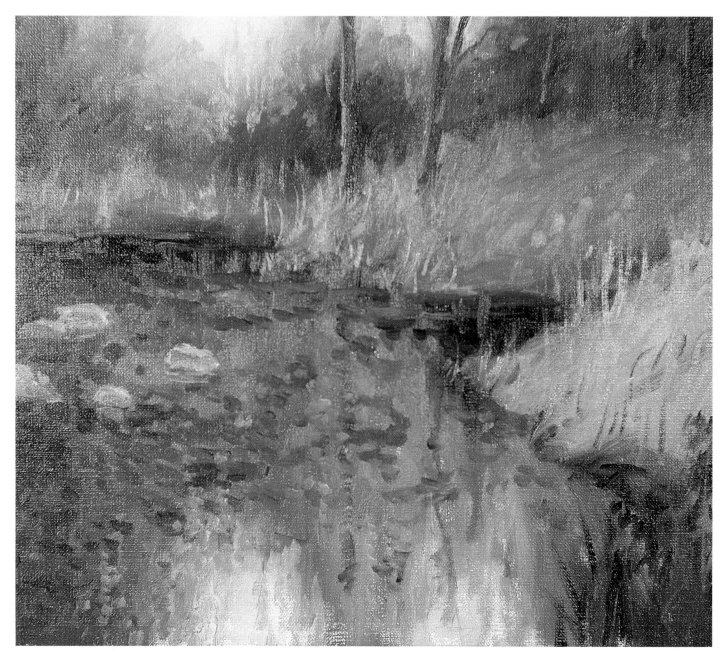

detail of the grass and shrubs and creek bed

After adding some light orange tints of sunlight to the tree trunks, detail the grass. In keeping with the mood of the painting, we don't want picky details so keep the grass soft and somewhat blurred. Use a thin, #00 round sable and make looping, upward strokes to indicate grass. Use the same mixture of Sap Green and Cadmium Yellow Light, but with more white. Again, this is because of the influence of sunlight striking the blades of grass.

Use much the same approach with the shrubs. Spot in a few lighter over dark areas and a few darker over light areas, that way, the details show up without becoming muddy. At this stage you can also add some twigs.

Using some Sap Green with Burnt Sienna add some rocks to the bed that are a bit darker than the underpaint. Next, use white and a touch of Burnt Sienna and paint the boulders with their reflections. Finally, added some rippled vertical lines of Cadmium Yellow Deep for the reflections of the trunks and sunlight.

keys to creeks

- When painting creeks, know ahead of time how you can use them to strengthen the design and the mood.

- Creeks can either be the subject or they may enhance a subject.

- They can carry a mood that relates to the theme of the composition or they may add a contrasting theme.

- Creeks may be slow with the S-curve, faster, rapid, shallow, or deep.

- Creeks may reflect objects around them, the ground and rocks beneath them, or reflect nothing more than light and shadow. It's your choice and there is no limit to how they may be used. The main thing to know is that creeks can greatly improve your compositions.

how on-site sketches help you to plan a major studio painting

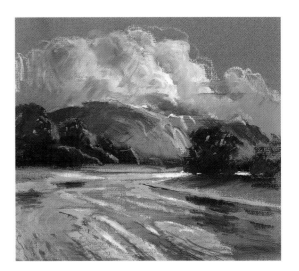

shallow, meandering creek with sky reflections — pastel sketch

The S-curve is nearly gone in this illustration, but the creek is still a meandering one. In fact, it is very shallow and broken into rivulets over sand, like the runoff in the desert after a flash flood. It mostly reflects the sky but also some trees, which gives it variety.

Desert Wash, oil,
16 x 12" (41 x 31cm)

When it came time to make this into an oil painting, I knew exactly how to proceed.

Notice that I changed the format to show more sky. Then I pushed the hills into the distance, graying them off to achieve aerial perspective. A darker hill in the middleground pushes the tonal range. Here the water serves as a reflector and brings the sky elements to the foreground for color harmony.

lakes and ponds

Lakes and ponds can be either shallow or deep, but they nearly always reflect what is around them. This gives you the opportunity to add mood to a painting that could otherwise be difficult to achieve.

People are naturally drawn to water. There's something about the stillness of lakes and ponds that seems to encourage personal reflection. Once someone is in this thoughtful state, water can be a powerful mood changer. For example: if a person is feeling anxious about a problem, staring into a quiet lake can change their mood to one of relaxation. If someone is feeling cold, a pond that reflects warm colors can warm up their mood. This capacity is something you must consider when you are composing a painting. You must always ask, "What mood am I trying to convey to the viewer?" because this is just as important as composing line, value, and color.

shallow water
Shallow water may be clear and objects may lie beneath the water. Quite often background reflections allow values and color to show. This gives us a way to add a particular mood to the scene.

deep water
Lakes are usually deep and therefore more reflective. Wind ripples and objects in the water can interfere with reflections, but this allows you to choose just how much of the water's area will be reflective.

Deep water, and water with a dark-valued background, seems deeper, allowing the viewer to define the painting's mood — their thoughts may be as deep as the water suggests.

The following illustrations will show you a number of ways that lakes and ponds can be used in a composition.

detail

Convict Lake, oil, 24 x 30" (61 x 76cm)

ACTION PLAN FOR SKETCH
adding a lake as a design element — oil

When water is not used as a subject in itself, it can still play an important role in a composition. In this sketch the mountains are dominant, with the sky and foreground sub-dominant. Even though the lake is incidental it still plays a big role. It adds an important water element to the scene, but the lake also allows a repeat of the sky color down to the middle-ground. Whenever we do this we enhance the color and value harmony of a painting. Without the lake, the painting might be nice but it would be less interesting and there would be less color harmony.

detail

ACTION PLAN FOR SKETCH
using a lake to support the focal point

I mentioned previously that the artist can control just how much reflection will show in water. Here is an example of how introducing some wind ripples broke the background reflections and changed the values behind the foreground trees. The focal point is the set of trees on the left of the foreground. The mountain is dominant in size, but not in value because it is faded with atmosphere. By breaking the dark reflection of the lake at just the right place, the tree trunks have a background contrast of light and dark values. The sparkle adds to the interest at that point.

"Deep water against a dark-valued background is perhaps the most reflective of all."

ACTION PLAN FOR SKETCH
creating mood through deep water — oil

Depending on your assessment this is either a small lake or a large pond. However, it is very deep, and is a good example of creating a mood with water. A person who views a painting that has dark values and very minor reflections will certainly feel the depth of the water and it will have an effect on their mood. Though there are background trees, rocks, and some reflections, the deep water is the focal point.

keys to lakes

- The mood of deep water invites the viewer to be introspective.
- Lakes allow you to reflect sky color in areas that need lifting.
- Use ripples to break up a large body of water.

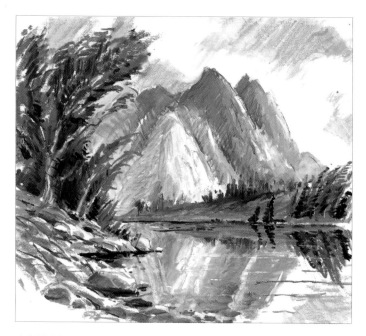

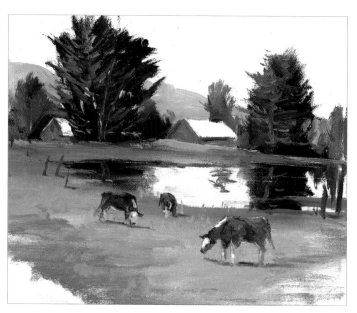

properly handling a lake that reflects a mountain — pastel

We have all seen postcards, photographs and paintings of beautiful mountains reflected in water. All too often, however, the reflection is a mirror image of the mountain and is therefore repetitious and distracting. You don't know whether it is upside-down or what, and because you are confused, more than likely you will turn away from it.

Having a mirror image is quite acceptable, but either the mountain or the reflection must be toned down. It is best to soften the colors, the edges and the values of the reflection and allow the mountain to be the center of interest. An exception to this would be when you feature more of the reflection than the mountain.

Note: Softening a mirror reflection applies to any background feature. Not just mountains.

using a pond to strengthen composition — oil

I cannot stress enough that designing an effective pattern of values, (light, medium, and dark) is more important even than color. A strong value composition will command far more attention than a weak one. No amount of color will read well if the values are weak. In this little farm sketch the pond allows for areas of light and dark below the background. Try to imagine this scene without the pond. There would be no repeat of background values and the entire foreground would be only a middle value.

reflecting both sky and background in a pond — pastel

Here is another example of not having an exact mirror image. The foreground pond is subdued, and the center of interest is the contrast between the dark trees and the golden trees behind them.

The foreground pond is also in shadow. Notice the blue sky color in the ripples of the foreground. In this painting the sky has no color, but the foreground ripples reflects blue. That is because the sky overhead, and out of sight, is blue. This in another way you can choose colors and values and place them where they are needed.

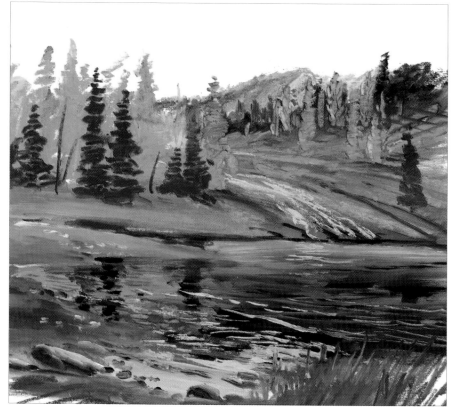

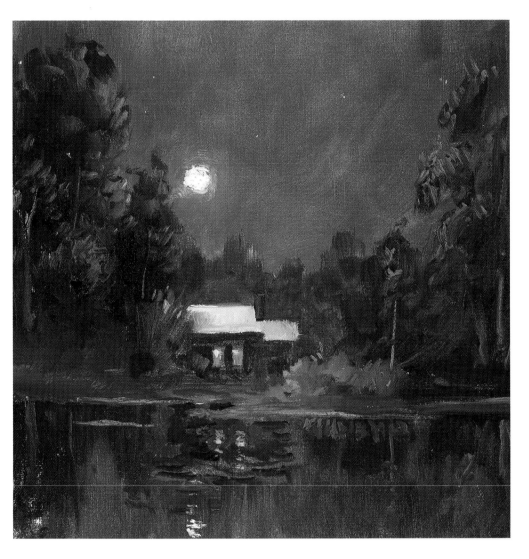

ACTION PLAN FOR SKETCH
reflecting night values and colors for harmony — oil

Night scenes automatically suggest mood. They can suggest cold or warm. They can be romantic in the moonlight, or dark and frightening. I made this sketch romantic and somewhat warm with some reddish-purple, and inviting by introducing the warm glow of light emanating from a cabin. The water simply reflects the colors and the values so the composition has overall harmony.

ACTION PLAN FOR SKETCH
reflecting dominant and sub-dominant values — pencil

When reflecting values you are showing areas of light, medium, and dark. One of the values should be dominant; that is, it should take up more space in your composition than the others. The other two values should take up less space and they should not be equal.

In this pencil sketch the dominant value is light. It takes up space in the sky, the foreground and in the trunks of the trees.

The sub-dominant value is dark; it takes up less space than the light and is used for the background trees and their reflections.

The middle value takes up even less space, but creates a balance that gives harmony.

Notice that a focal point — where the snags on the left are in front of the darker trees — has been achieved because the lightest light is next to the darkest dark.

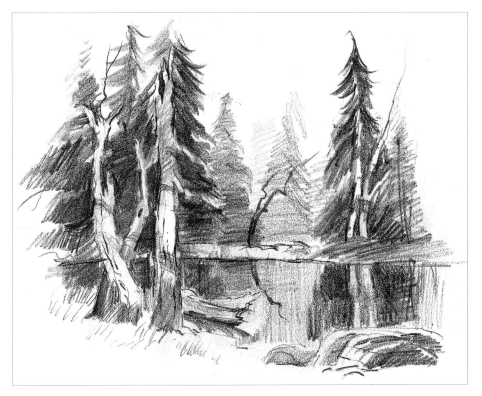

ACTION PLAN
FOR SKETCH

understanding and portraying what water sees and what the eye sees — watercolor

Here is an example where the reflections tell more than the background. For one thing, the reflecting water takes up more space than what it is reflecting, and for another, it is showing more detail. This is quite different from featuring the background and subduing the reflections. What is happening here relates to what the viewer can see and what the water can see. The strong background light diffuses the trees and softens their edges so we cannot see all of the details. The water, on the other hand, "sees" what is above it and does not see as much diffusion as we do. Therefore water can reflect more details and values and even the overhead sky.

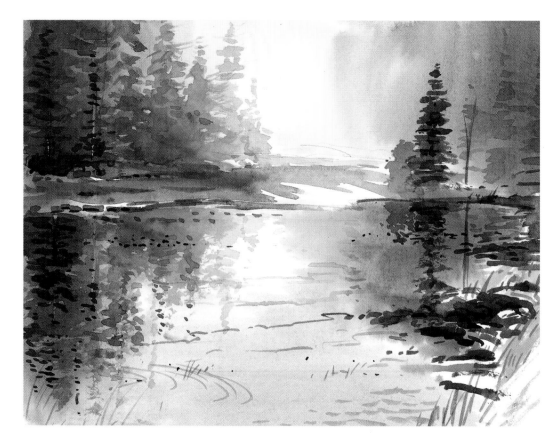

ACTION PLAN
FOR SKETCH

making water look cold — watercolor

I have included this sketch to show how to suggest cold water. Of course the snow sets the "temperature" of this scene, but the dark blue water, without a hint of warmth, underscores the coldness.

The water is dark and deep, but may not tempt a viewer to contemplate it in a reflective way. This is partly due to the coldness, but mostly because the water is only a background to the trees, and the main tree is the focal point. The lightest value on the tree sits against the darkest value on the water so the eye is automatically drawn to that area. So, even though the water serves as a background in this example, it plays two very important roles in this sketch.

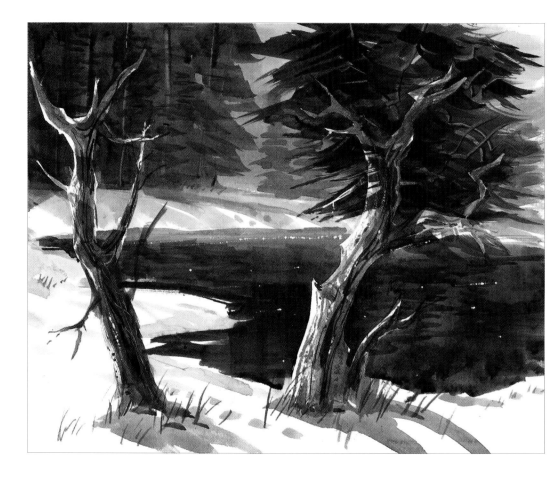

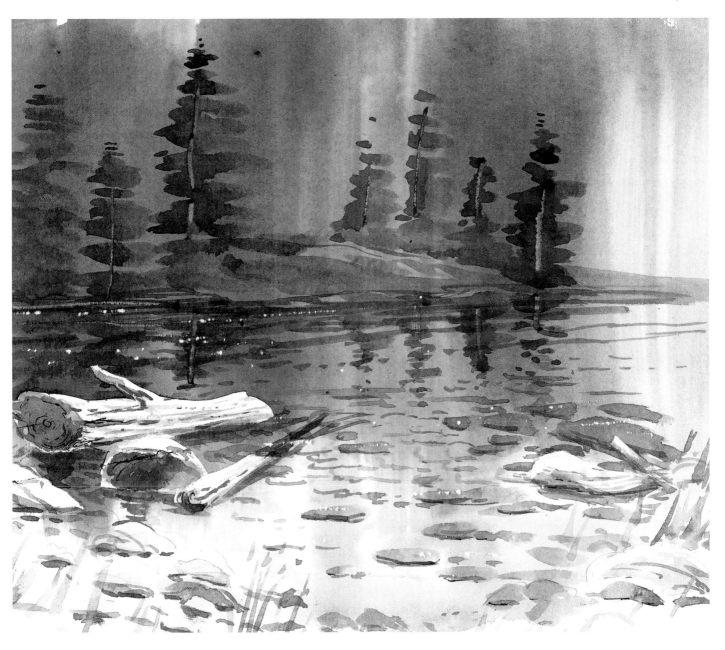

ACTION PLAN FOR SKETCH

manipulating the elements in a shallow pond — watercolor

Shallow water allows us to see objects beneath the surface — rocks, mud, pieces of wood or even fish. In this case, you have a choice as to how much to show below the surface and how much you allow the surface to reflect what is above. In this example, I chose to let the shallow water be dominant and have reflecting water as a sub-dominant feature. Notice how I used a few sparkles to indicate the surface above the submerged rocks. Without the logs and the sparkles this might look more like a mud flat with some rocks than clear water.

keys for ponds

- Shallow water gives the opportunity to show objects beneath the water.
- To prevent ponds looking like mudflats, introduce sparkle and objects peeping above the surface.
- To suggest depth, use dark values and minor reflections.

"Soft colors are more relaxing than strong ones; softer edges less demanding of the attention than hard ones."

art in the making
reflecting soft colors and edges to create a relaxing, restful mood — in oils

This is a scene where a pond reflects the last light of day. It is a time of quiet reflection, but unlike the demonstration for creeks in chapter six, this time we will use softer colors and softer edges which will change the mood immediately.

Soft colors are more relaxing than strong ones; softer edges are less demanding of the attention than hard ones. The water will be used more for reflecting colors and values than as a center of interest. The sun, about to sink behind the mountain, is the focal point but will also reflect back to the viewer. The golden light will touch the middle ground trees and leaves and then be reflected even more in the pond. I chose to use broken color much like the Impressionists to soften colors and edges and introduce a shimmer of light on the water's surface.

ACTION PLAN FOR EXERCISE
The overall mood should be one of quiet relaxation and restfulness achieved through soft colors and soft edges. The water will serve to reflect the color and value.

what you will need

oil palette

ULTRAMARINE BLUE SAP GREEN CADMIUM YELLOW DEEP

BURNT SIENNA ALIZARIN CRIMSON TITANIUM WHITE

brushes
#3 filbert oil brush
#8 filbert oil brush
#1 round oil brush
#2 round oil brush
#0, #1 and #2 sable or synthetic brushes

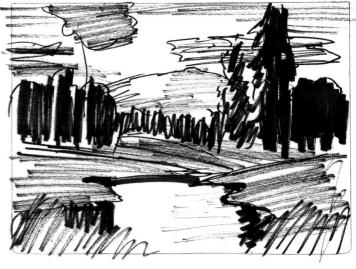

value sketch
If you have worked out your composition with values, colors, mood, and center of interest ahead of time, then a quick outline is all that is needed to get started.

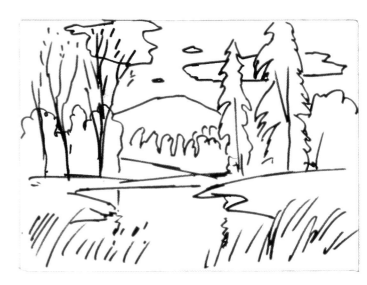

preliminary drawing

step 1: make an outline

There are many ways to begin a painting: You could use an underwash of a particular color or value; you could make a complete rendering in black and white values, a series of glazes with color, or you could embark on an impasto build-up — to name just a few.

For this painting, draw a simple outline using thinned Ultramarine Blue and your #3 filbert oil brush.

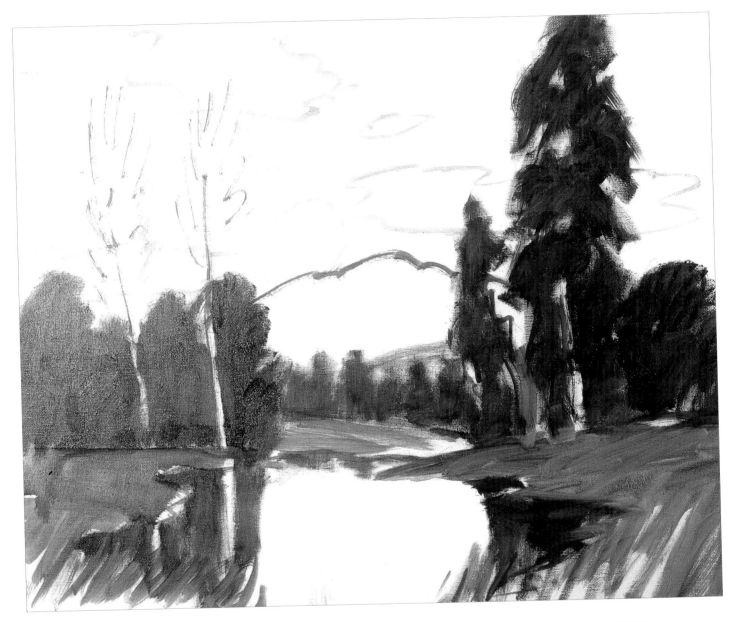

step 2: establish the dark values

It is always a good idea to establish your dark values first because everything afterwards will be lighter. I have seen students begin with a sky that is too dark and then the real dark areas become lost or the whole painting is too dark.

For the darks, mix Sap Green and Alizarin Crimson but allow a bit more of the red for a warmer dark. Using a #8 filbert, scrub in the underpaint of the major trees *without using white paint or thinner*. (If you use white paint in dark underpaint it not only takes away from the value, it creates a chalky look.) Next, add a little thinner and scrub in the same mixture for the central background and the ground on each side of the pond. Indicate the tree reflections.

SAP GREEN · ALIZARIN CRIMSON

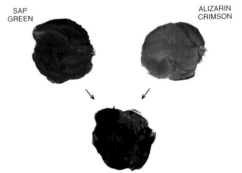

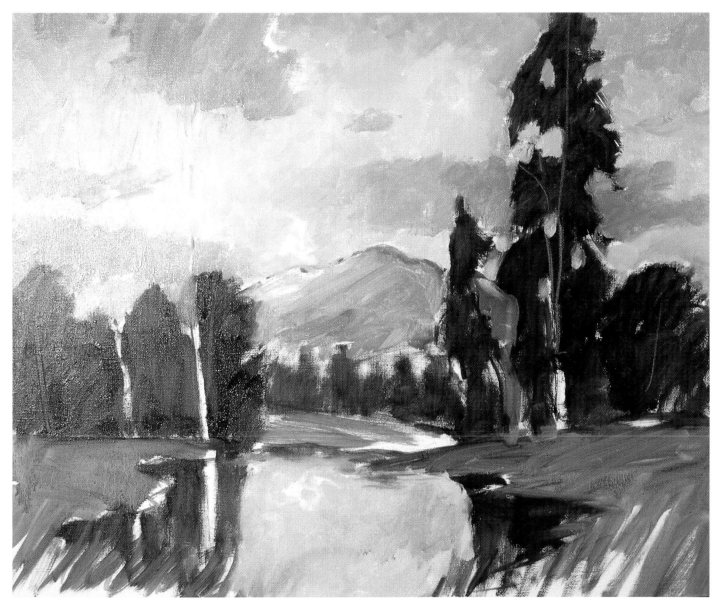

step 3: underpaint the sky sky and pond

The aim is to create a sky that is lighter near the sun and which becomes gradually darker further out. In this case, begin with the outer edges using a #8 filbert and a mixture of Ultramarine Blue and Titanium White. Paint this value for about three-inches on both outer edges toward the area of the sun. Next, add a bit more white and paint another couple of inches. But now the sky is nearing the area of sun and needs to begin reflecting its colors. So, mix Cadmium Yellow Deep and a touch of Alizarin Crimson into Titanium White and add it to the sky color you just used. Paint a bit more of this all around the sun and gradually blend it outward so there is not be a line between the two colors. Finally, use Cadmium Yellow Deep and Alizarin Crimson mixed with Titanium White near the sun. Paint the same colors in the pond area, but use broken brushstrokes for a shimmer effect.

For the clouds and the mountain in the background use Ultramarine Blue and Alizarin Crimson, making them a bit darker than the sky behind them.

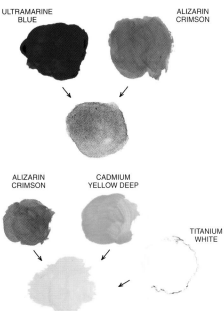

ULTRAMARINE BLUE

ALIZARIN CRIMSON

ALIZARIN CRIMSON

CADMIUM YELLOW DEEP

TITANIUM WHITE

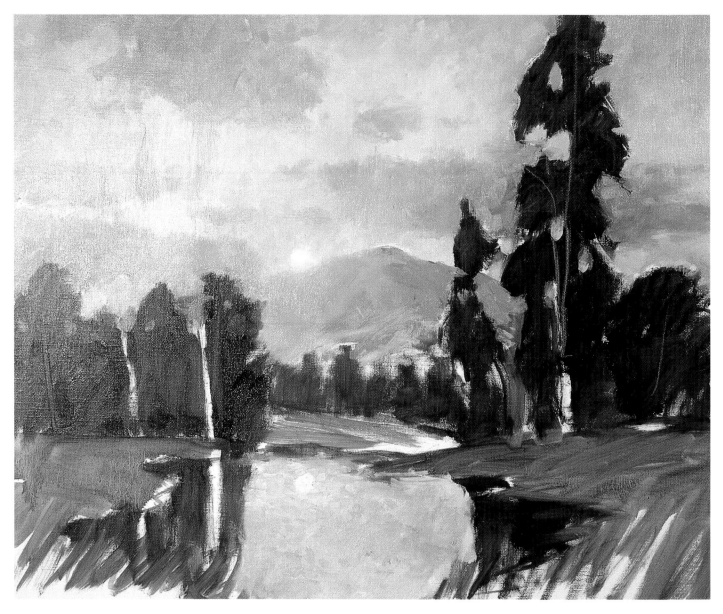

step 4: refine the sky and reflections

Because we want a blurred effect, smooth out any hard-edged brushstrokes around the sun. Add a bit more Cadmium Yellow Deep mixed with a little Titanium White and apply with a #1 round. Use pure Titanium White for the sun itself. This gives a halo effect around the sun. Add more yellow to the edges of the clouds and also spread the halo down over the mountain. The sky is a bit flat, so daub a few broken brushstrokes over it with Ultramarine Blue and Alizarin Crimson mixed with a bit of white. Do the same in the pond enhancing the shimmer effect.

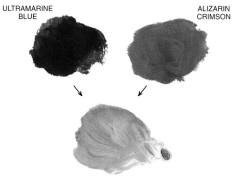

ULTRAMARINE
BLUE

ALIZARIN
CRIMSON

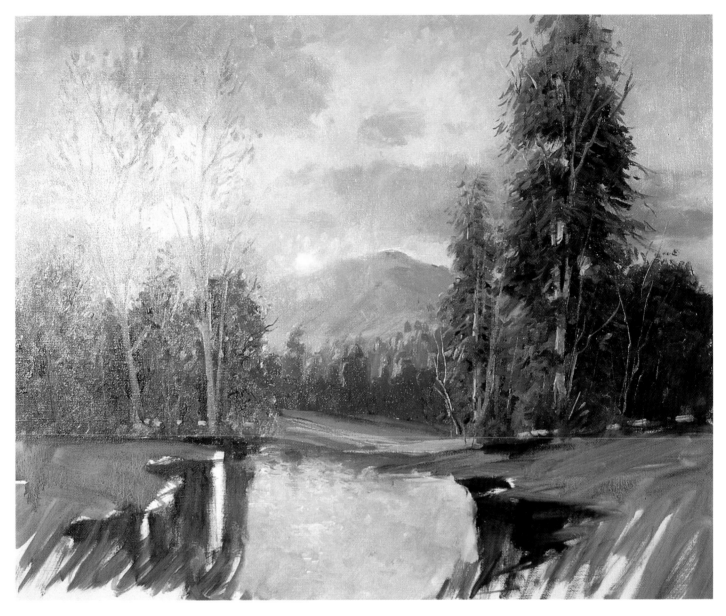

step 5: refine the trees

With a #2 round brush paint the trunks and a few leaves of the bare trees on the left. Use Ultramarine Blue and Alizarin Crimson. Then touch in a few leaves of yellow-white to suggest reflection from the sun. For the background trees use Ultramarine Blue and Alizarin Crimson with a bit of Titanium White and touch in a bit of the sun's color.

The middleground trees can be overpainted next using Sap Green and Alizarin Crimson, but with some white added. Dab in these colors with a #3 round but be careful to leave areas of underpaint showing. Behind them you can paint the meadow using Sap Green, Burnt Sienna, and a touch of Titanium White. Add the sun's glow to the outer edges of the trees.

The major trees on the right can be painted the same as the dark trees on the left. Paint the trunks for both trees using a mixture of Burnt Sienna and Titanium White, then with Ultramarine Blue and Titanium White. Again, add a few touches of sunlight to the edges but also a few dabs of sky color so the trees will not be flat and too dense.

SAP GREEN

ALIZARIN CRIMSON

BURNT SIENNA + WHITE

ULTRAMARINE BLUE + WHITE

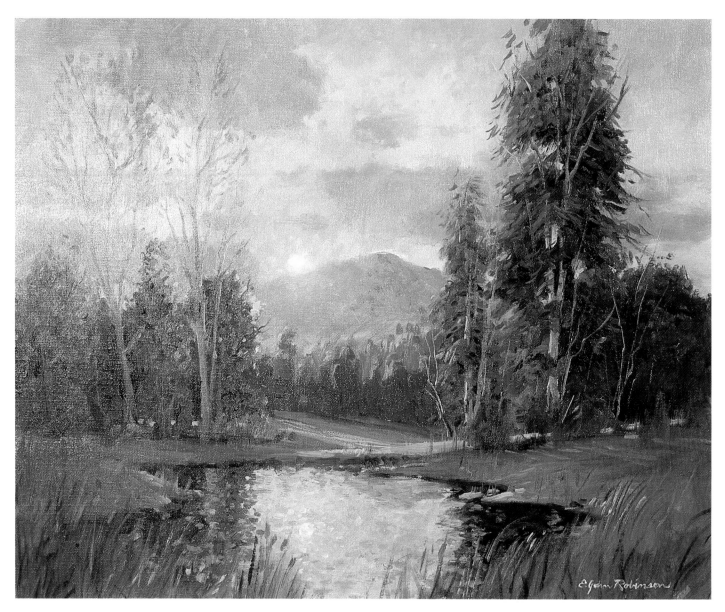

step 6: finish the foreground

Pond: Add more broken reflected colors from the sky and the trees and interchange the light and dark values where they meet — this softens the edges and adds even more shimmer effects.

Ground and grass: Use Burnt Sienna and a bit of Sap Green with Titanium White for the ground. Use a #3 filbert, add some blue-red shadows on each side below the dark trees. Make a few upward strokes to give the effect of grass growing in front of the bases of the trees. The foreground grass can be painted with small brushes: #s 0, 1, and 2 sables. Use more upward strokes with a variation of Burnt Sienna, Sap Green with some Titanium White, and introduce the colors used for the sun here and there.

SAP GREEN

BURNT SIENNA

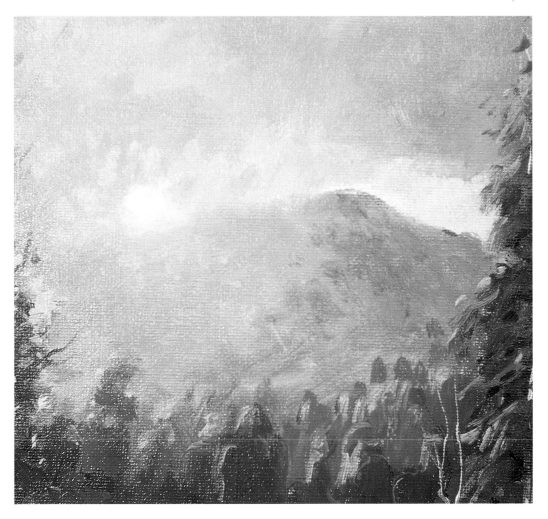

detail

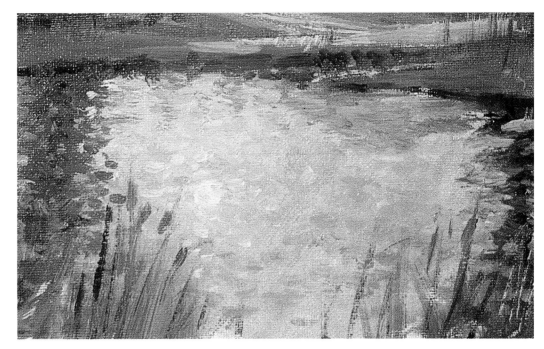

detail

chapter 8

rivers

There's a mystical, magical quality about rivers. Once you understand
this you will be able to create paintings full of drama and meaning.

Y ou could say that rivers are nothing more than big
creeks, but they offer certain aspects that creeks
cannot. For example: Rivers can be very deep and therefore
they create a much different mood than a creek. They can
also be much larger and therefore more violent in action,
which adds another mood element Finally, rivers are a
metaphor for the journey through life or time — a very
profound mood, to be sure.

Keep in mind that water can easily be the subject of a
painting but its main purpose is to reflect. Decide the mood
of your painting first, regardless of the scene, then use
water to reflect or enhance that mood. Remember, a mood
can be happy or sad, quiet or rushing, or it may cause the
viewer to think deeply. There are endless moods that can be
the theme of a painting so once you have chosen one, you
may then use an aspect of water to reflect it.

Clapper bridge, oil, 15 x 30" (38 x 76cm)

the powerful mood of the river

Rivers are dear to my heart because I spent my high school
years in a small town on the Rogue River in southern
Oregon. I have many memories of fishing, swimming,
floating on a raft, shooting cascades in a kayak and just
sitting and staring into the depths.

The river is truly a metaphor for a person's journey through
life: born from the skies, a river starts out small and grows
larger until it becomes full grown; it is sometimes shallow
and sometimes deep; it can be fast or slow, quiet or violent,
and it makes its journey past all kinds of terrain until it finally
reaches the great beyond — the sea. There, it recycles to the
sky and begins a new journey somewhere else. Even if you
have never considered or appreciated this metaphor, any
composition in which you include a river will be viewed by
others whose unconscious may respond to it in a metaphorical
way. So you see, anything that provokes such powerful moods
needs to be understood so you can paint it successfully.

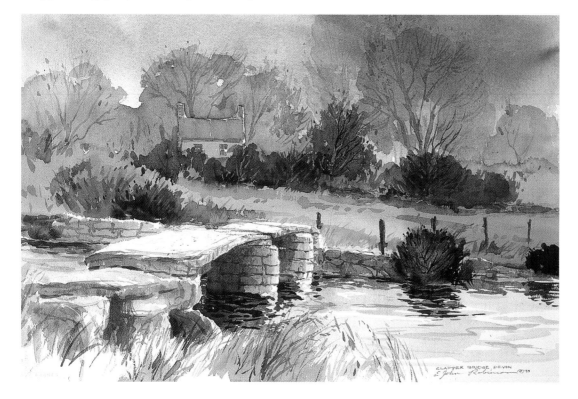

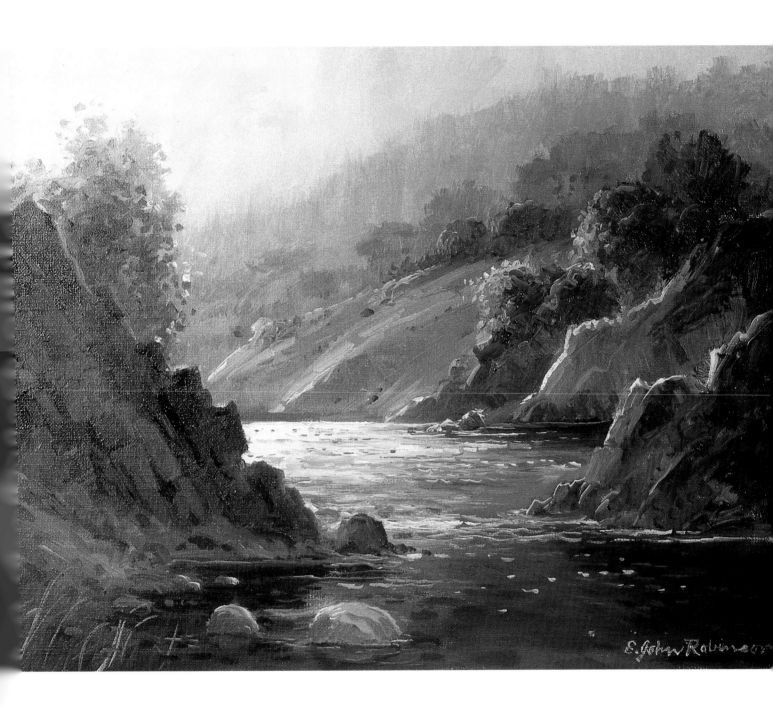

E. John Robinson

"Rippled water still reflects all the colors above it, but it distorts the image."

ACTION PLAN FOR SKETCH
reflecting color in smooth, quiet water — watercolor

When a river is very wide and deep it sometimes seems as if it isn't moving; almost as if it were a pond. This aspect allows you to reflect a mirror image of anything you wants to portray. In this case, I chose quiet water to reflect color. Try to picture this sketch without the tree reflections. The composition would be less interesting and off-balance. By reflecting the colorful trees I extended the color as well as the subject. The viewer's eyes are drawn to bright colors, and the reflections add to the mood of quietness, as well as depth.

ACTION PLAN FOR SKETCH
aiming for light, movement and the shimmer effect — pastel

A slow movement, and a mild breeze makes the surface of water slightly rippled. This gives a shimmering effect that you can use when you don't want mirror images. Rippled water still reflects all the colors above it, but it distorts the image. Using broken reflections prevents monotony and, again, you can choose just how much, or how little, of the reflections you want to show.

ACTION PLAN
FOR SKETCH
using riffles to obscure distracting reflections — oil

Riffles happen on faster moving water and they can be caused by wind.

The amount of reflection you include in this situation is truly up you. In this sketch, the figure is the focal point. If I had made the water smooth the necessary, authentic reflections would have been too distracting. In this case I used the moving water to obscure any reflections in the background, and to add just enough interest in the foreground. Remember, you are the director of a scene and it is your choice of how to display it.

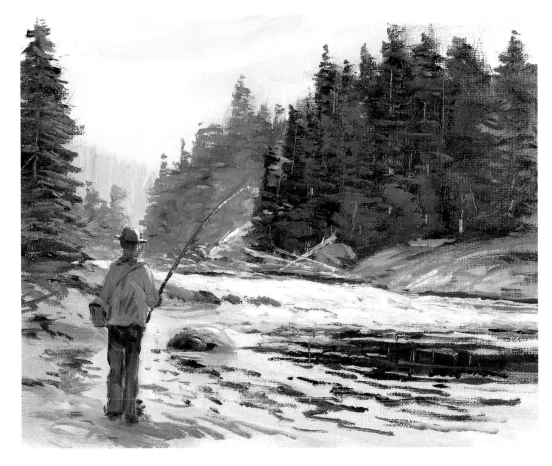

ACTION PLAN
FOR SKETCH
breaking up rapids with sunlight and shadow — oil

Rapids (or white-water) are caused by steep, downhill drops. They are, as the name suggests, the fastest moving water conditions, except for waterfalls. Very little is reflected because they are usually too aerated, or foamy. Much of the foam and spray is caused by striking rocks as well as fast movement. When the rapids are foaming, as in this sketch, it is best to use sunlight and shadow to break them up. Remember, too much white water can be monotonous.

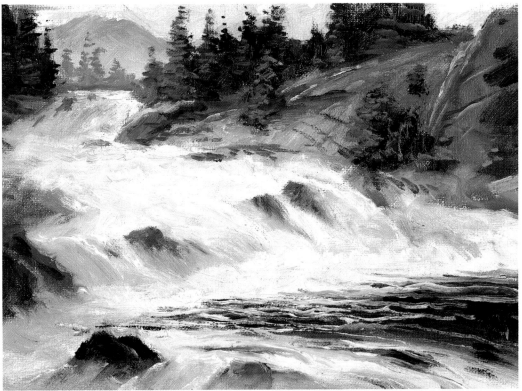

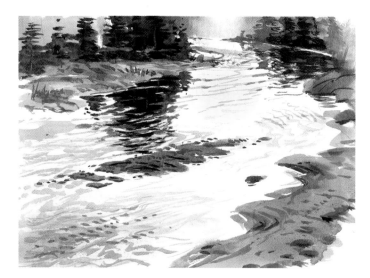

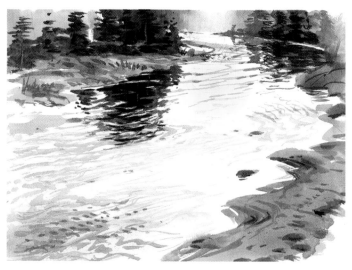

ACTION PLAN FOR SKETCH
breaking large areas with exposed ground and a rippled surface — watercolor

A rippled surface is more than shimmer, but less than faster moving water. Here, the river is shallow and there is a section of exposed ground as well as the rippled reflections to break up the image. The ripples also break up the surface and add interest as well as add some color that is reflected from outside the composition — another important use in any composition.

here it is without the exposed ground
In this computer-generated image we doctored out the exposed ground so you can see that without this, the area is too large.

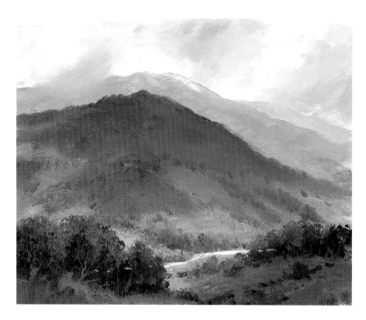

ACTION PLAN FOR SKETCH
using distant water for contrast — oil

In this sketch, water is the center of interest even though it is the smallest area in the composition. The mood created is one of relief in an otherwise dry atmosphere. From this viewpoint high above the narrow valley you can see for miles into the distance. The distant river captures your attention because of its movement, and because as an eyepath it shows a way out of the scene.

ACTION PLAN FOR SKETCH
including water in a supporting role — oil

Here is another example where water is not meant to be the center of interest. In this sketch the bridge is the focal point and the water is used only for values and colors in the composition. It doesn't even reflect the bridge. These are choices you must make and by understanding the possibilities, you will be able to compose with much more variety and combinations of effects.

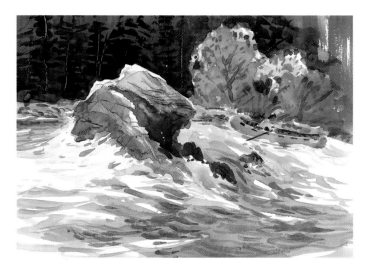

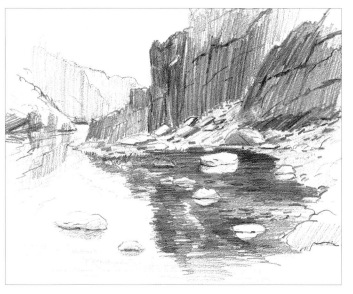

ACTION PLAN FOR SKETCH
using water for drama — watercolor

As we now know, water can set many moods in a composition, and it can play supporting roles as well as being the center of interest. In this sketch the center of interest is the figure on the raft shooting rapids on a white-water river. Here, the water acts as a supporting role by showing the power of the river. Without it splashing up on a rock and moving rapidly over a cascade, the drama of the rafter would be lost. The large expanse of water in the composition dwarfs the raft suggesting the might of nature, and adding to the mood.

IMPORTANT POINT
learning to see the values in color

It is very important to understand values in any composition. I recommend you do a lot of preliminary sketching with pencil because it will help you to see values without color getting in the way. For instance, in this value sketch I discovered the importance of the light rocks against the dark reflections of the bluffs. Had I worked straightaway in color I might not have been as observant.

"Too often students do not understand that color has value, and their compositions suffer because of it."

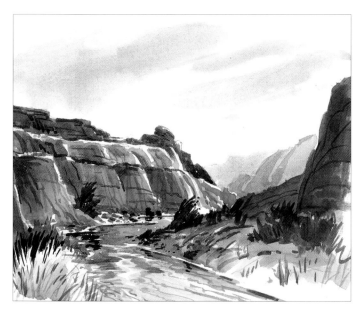

ACTION PLAN FOR SKETCH
making water mysterious and contrasting — watercolor

Water can lead the eye into a composition and to a center of interest as it does in this sketch, However, its continuation is obscured and we are left wondering what lies beyond the bend? I personally like this kind of mood because it makes viewers curious. I know the same effect can be created with a road or a path, but in this case water is the important element because it also contrasts with the dry, desert landscape.

keys to rivers

- River depth allows you to create unique moods.
- River volume allows you to inject movement and drama.
- Rivers are a metaphor for the journey through life.

art in the making suggesting distance and mood in opaque watercolor

In this demonstration we will be using watercolors, but will correct the values of the composition using white gouache. Therefore, this painting is technically an opaque watercolor rather than a transparent watercolor. This is just another way to paint, and you must choose the technique that best suits you.

GOAL OF THE EXERCISE
To suggest the effects of distance with gradated tonal values and show you how you can control this by using white watercolor or gouache paint to gray colors off.

what you will need

watercolor palette

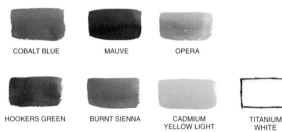

COBALT BLUE	MAUVE	OPERA	
HOOKERS GREEN	BURNT SIENNA	CADMIUM YELLOW LIGHT	TITANIUM WHITE

1" flat brush
#12 round sable or synthetic brush
sponge
paper

value sketch
This value sketch clearly shows where the darks, mid-values and lights are. You can then translate those values to your colors!

outline
Here is the shape outline. This shows you the foreground, middleground and background planes and also serves as your tonal value map — colors in the foreground are intense and dark, colors in the middleground are mid tones and those in the distance are grayed-off.

NOTE
You can make colors darker by using less water and more pigment, or by adding more dark color.

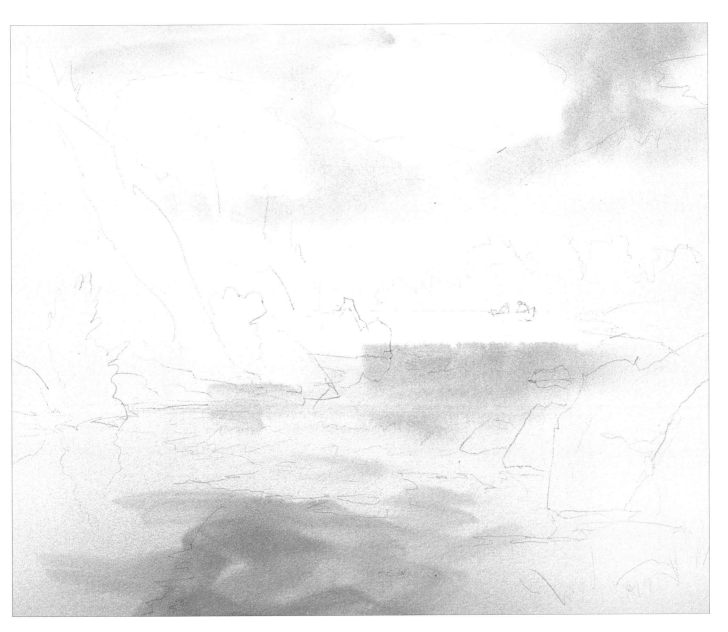

step 1: underpaint the sky and reflections

Wet the paper with a sponge. Mix up some Cobalt Blue and a touch of Mauve in water and using your 1" flat brush paint the sky, leaving the clouds unpainted. Quickly repeat the color in the area of the river, leaving some white paper for later reflections. Allow the sky color to run down over the area of the background hills.

COBALT
BLUE

MAUVE

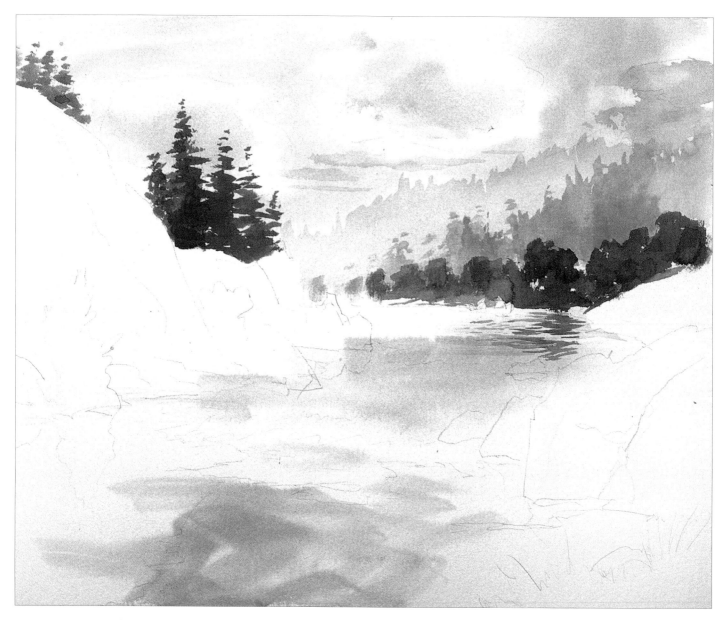

step 2: paint the background

While the paper is still a bit damp, use the same brush, darken the intial sky color with a bit of Cobalt Blue and then complete the clouds, making sure to leave the outer edges of the clouds white to give the effect of backlighting.

Be conscious from here on that there are two people in a boat who need to be painted. Preserve that area. Paint the background trees in three stages using your 1" brush. First mix up the same color as the sky, but darkened a bit more with Cobalt Blue, then paint the far distant trees. For the middle area of trees use the same color but darkened yet again with more Cobalt Blue.

Finally, paint the darkest trees with the same mixture, but this time darkened with Mauve and Hookers Green. Paint the trees on the upper left the same, but this color will be an underpaint. Leave the two trees on the foreshore.

COBALT BLUE

MAUVE

HOOKERS GREEN

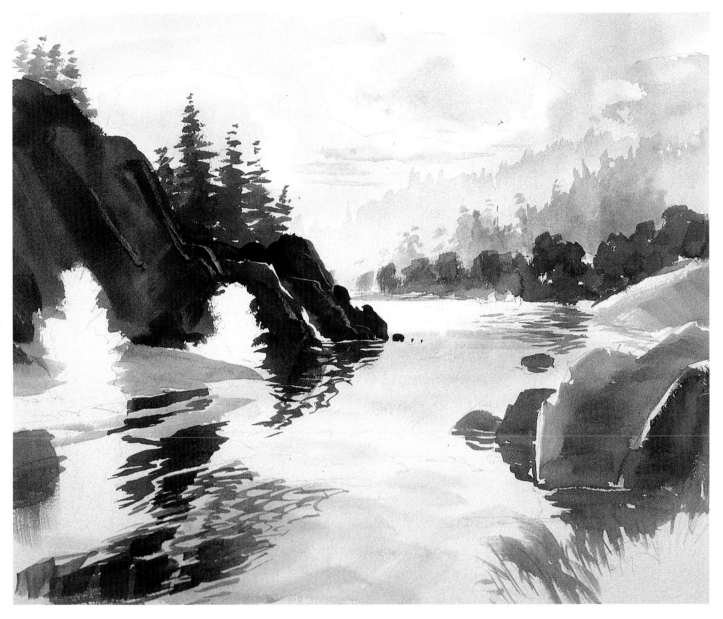

step 3: underpaint the bluffs and rocks

Mix the rock color from Burnt Sienna and Mauve. Apply this with your 1" brush to the rocks on the left — it should be quite dark. Paint around the two foreshore trees on the left. Then use the same color, but this time with much more water, for the lighter rocks on the right. Leave some edges unpainted to suggest the effects of sunlight.

While the rock colors are still wet, "charge" them by adding dabs of Cobalt Blue, Hookers Green and Opera. This gives the rocks a more colorful look, and prevents the sameness that would otherwise result.

BURNT SIENNA

MAUVE

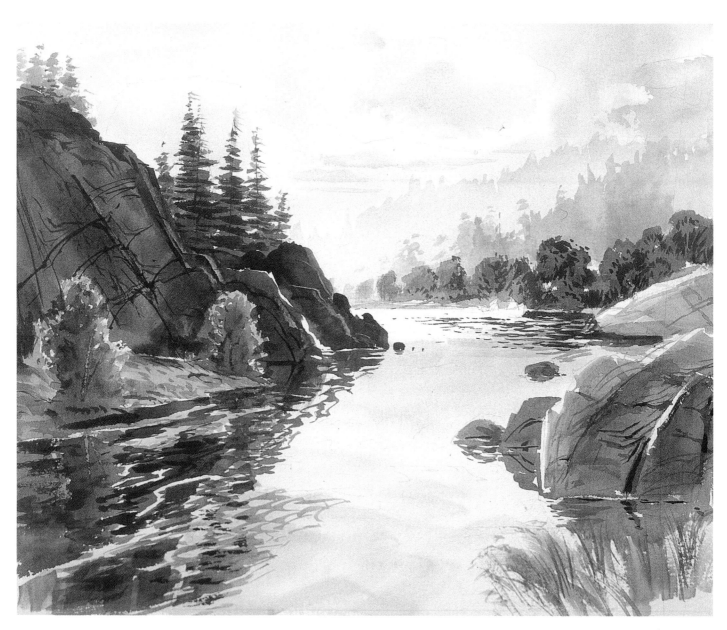

step 4: detail rocks and trees

Now it's time to use your #12 round sable and begin detailing
the background trees using slightly darker version of their base
colors. For the darker trees, use Hookers Green and Mauve. Your
brushstrokes should repeat the form of the branches and boughs.
Use the same colors for the reflections in the water.

Paint the two foreshore trees beneath the bluff in two stages.
First paint the outer edges using Cadmium Yellow Light and a touch
of Hookers Green. Next, paint the interior of the trees using Hookers
Green and Burnt Sienna, which should also be reflected in the water.
You should have achieved an attractive halo effect from the
backlighting.

When you texture the rocks, keep this to a minimum with just
a few strokes for cracks and spots, and make it just slightly darker
than the base colors.

HOOKERS
GREEN

BURNT
SIENNA

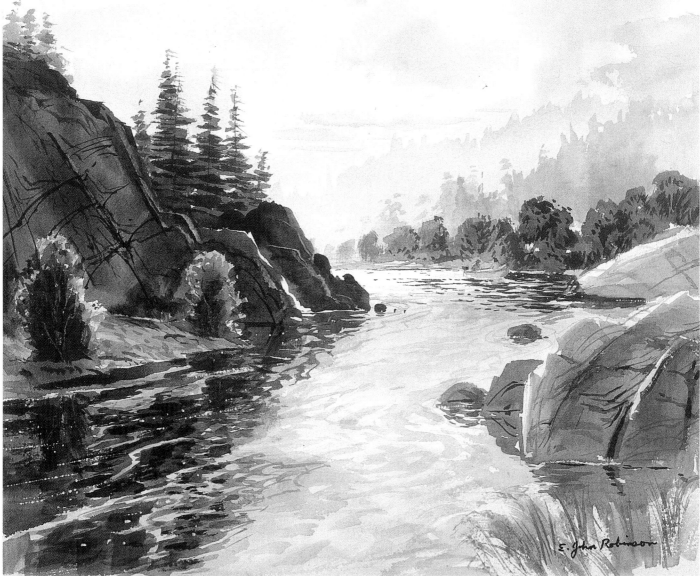

step 5: detail the river

Use the tip of your #12 brush for the boat and figures. You won't
need to paint many details because the river is more important in this
composition. Add a few light strokes to reflect clouds that may be
higher in the sky than the painting shows.

This is where you introduce the figures and the boat. Notice how
the colors are the correct value for the background. Adding bright
accents of color to distant figures will ruin the effect of distance that
we are working to create.

detail

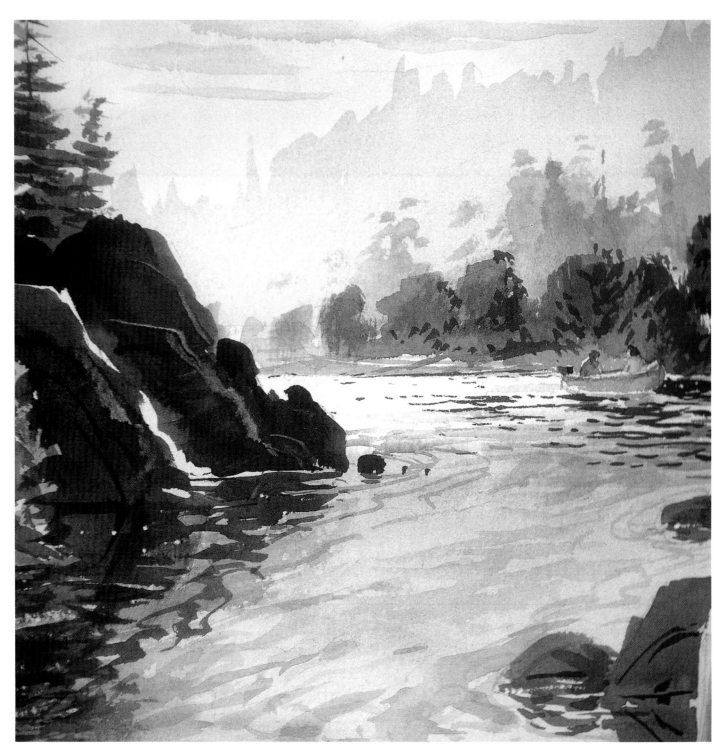

step 6: detail
This close-up gives you a better idea of the main progress so far.
The ripples on the river should be kept only slightly darker than
the base paint, otherwise they will be too harsh.

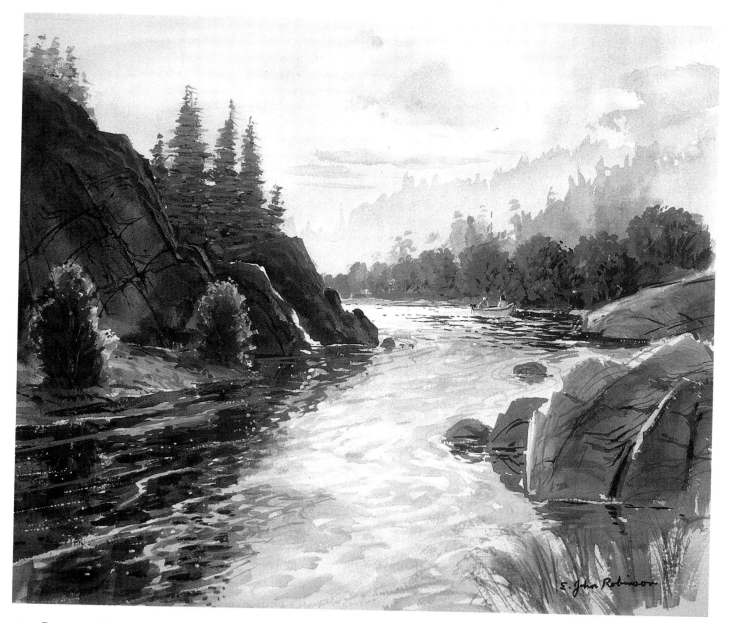

COLORS TINTED WITH WHITE

step 7: now subdue the values using white

Many artists paint beautiful watercolors using white paint for variations throughout the process. In some cases it is only used for corrections, and that is what you will do next in this exercise. Here I am going to show you how to correct the values to minimize contrast and emphasize the effects of distance even more.

Before you start, I want you to compare this finished painting with the previous stage on page 85 to see the subtle change that makes all the difference.

Now, in certain areas I want you to add white gouache or white watercolor to the same colors you used previously. You will need to tone down the background trees, the last bluff and the last rock. Add some white to the bluff colors and introduce some light passages in the nearest bluff, the foreshore and some of the reflections. Compare this with the last stage to see what needs to be done next.

Finally, using a sharp knife, pick out some sparkles and a few motion lines, especially over the dark reflections on the left.

chapter 9

waterfalls

The most crucial things to introduce into your waterfalls are shadow and color.

Water is never so dramatic as when it falls. Whether it drops a few feet or a few hundred, the effect is one that causes us to stop and look in awe at the scene. Waterfalls may be large or small, trickling or powerful, quiet or thundering, but they all catch our attention. As well as their beauty, who can resist the sound of water striking rocks or falling into a pool? Waterfalls create different moods to still or slowly moving surface water. Falling water is water in its most active form — it is the release of energy that we feel and respond to. We may be lulled into quiet ease beside small waterfalls or we may feel dwarfed and overwhelmed by large ones.

Waterfalls have certain basic forms, but there are countless ways to portray them. In this chapter, we will look at several of the forms using different approaches with color and composition.

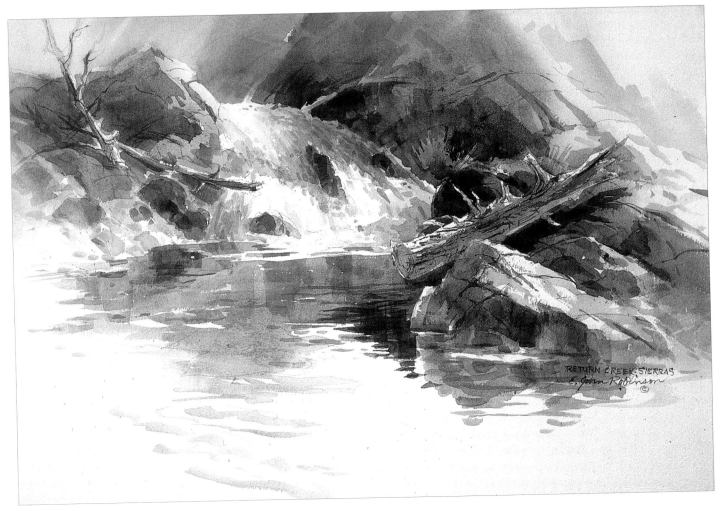

Sierra Falls, watercolor, 15 x 24" (38 x 61cm)

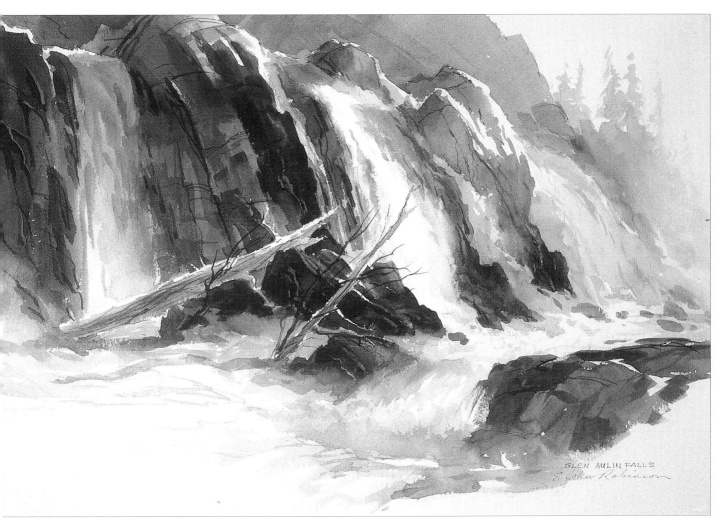

Glen Aulin Falls, watercolor, 15 x 24" (38 x 61 cm)

"In reality, falling water aerates and therefore loses color and reflective qualities, so it appears to be white. However, in a painting an all-white waterfall may be too much white and will therefore be uninteresting."

casting shadows for interest and color

One of the most important lessons to be learned is the art of casting shadows. It is a way to avoid monotony, to create an area of interest, and to add richness of color. In reality, falling water aerates and therefore loses color and reflective qualities, so it appears to be white. However, in a painting an all-white waterfall may be too much white and therefore uninteresting. The answer is to divide it between light and shadow. As an artist, you can choose just how much light and shadow you want and you know to create an unequal division to avoid sameness. In most mediums the effect of light and shadow can be applied as you go but in watercolor, I like to cast the shadows first, then work over it after it has dried.

Here, I applied some varied blue-purple tones dividing the area in shadow. I kept the area to be pure white as the white of the paper.

Next, I applied my glazes and added details to the white paper at the top of the falls and to the pool at the bottom.

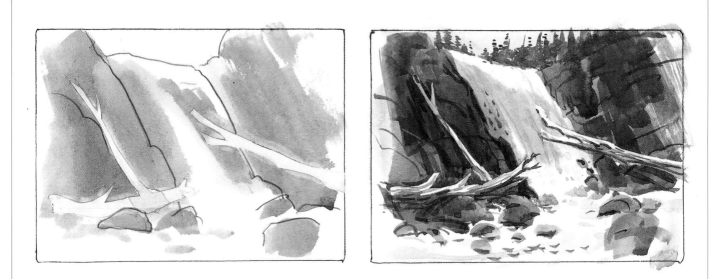

how to preserve whites and highlights using masking tape instead of masking fluid

I have never had good luck with the rubber cement types of masking fluids. They never seem to do what I want them to do and the results often look like white worms. What I prefer doing takes no longer but gives me much more control; I first draw the shape of an object, then lay masking tape over the drawing, making sure I have covered the entire shape. Then I take a razor blade or a very fine edged knife and cut away the tape I don't

want. The pencil lines show through so it is easy to cut out what is not needed.

I paint the background, whether it is shadow or underpaint. Then I go on to details before removing the tape. Once the tape is removed I can add color, shadow and textures to the clean white surface.

The demonstration beginning on page 96 includes this method.

"One of the most important lessons to learn is the art of casting shadows. It is a way to avoid monotony, to create an area of interest and to add richness of color."

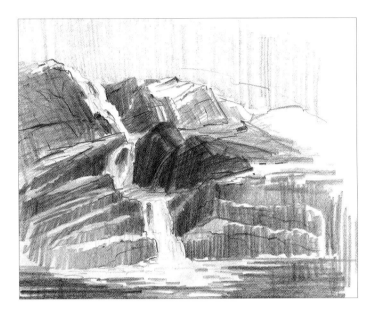

ACTION PLAN FOR SKETCH
dividing narrow trickles into drops — pencil

Trickles are the smallest of waterfalls but they are still falling water and need the same attention as large ones. Always select areas to be in shadow and in light. Trickles look better if they meander a bit which is something large waterfalls cannot do. Make sure the meandering is divided into segments of different lengths. It also looks better if the segments change direction as well.

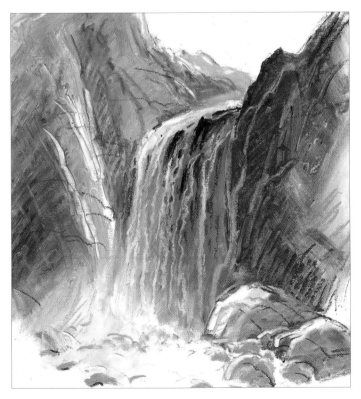

ACTION PLAN FOR SKETCH
showing rock color through the falls — pastel

Not all falls consist of spuming water. Some falls, even large ones, trickle in a thin veil. A lot of rock can show through the water, and if the base rock is knobby or textured, the trickling may form a lace-like pattern. In this illustration, note the areas selected for light and shadow.

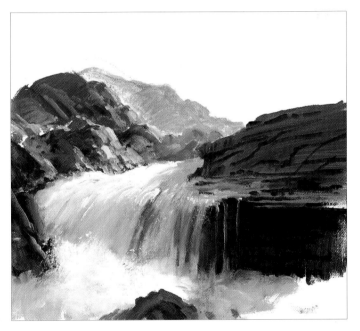

ACTION PLAN FOR SKETCH
combining heavy flow with contrasting trickles for short falls — oil

Sometimes even though falls are very short, they are still aerated water. In this example the water is squeezed between rocks in a narrow gorge and the flow is quite forceful. There is just a hint of rock color beneath the falls and the foam below is so heavy that no rocks can be seen. Notice also how I combined the heavy flow with a contrast of trickles. This is another way to add interest and avoid sameness.

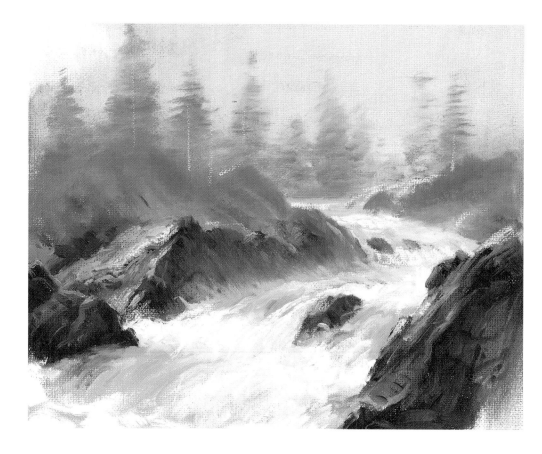

choosing one star in a ladder falls — oil

This form could also be called a rapids, but I think of rapids in rivers and this is a narrow creek.

Notice how the water flows fairly horizontally then drops in a series of stages. When painting this type of falls, it is very important to make only one of the areas stand out. Notice also the meandering line of the ladder falls. It is a variation of the S-curve. Also notice that the interest is in the foreground — the strong light and sharp features of the rocks. I deliberately faded the background with softer colors and less detail so it wouldn't distract from the foreground.

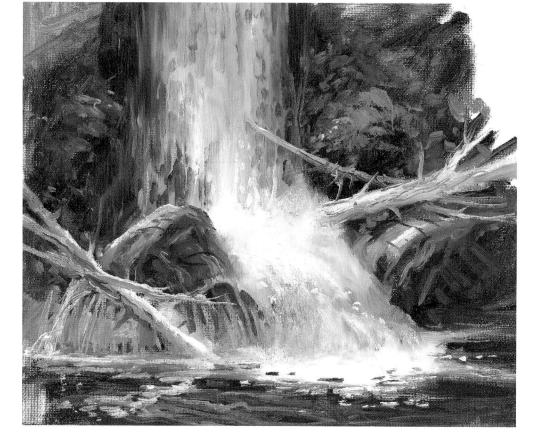

handling a two-segment falls with light and direction — oil

Sometimes, rather than painting the entire falls, it is best to paint only a section of it. In this case I chose to paint the lower part of a falls that has two segments. It first drops down from shadows to a ledge in sunlight, then falls again for a short space to the pool below. When composing this type of falls be sure to make the segments different lengths as well as in light and shadow. Notice how the fallen logs give direction as well as interest to the scene.

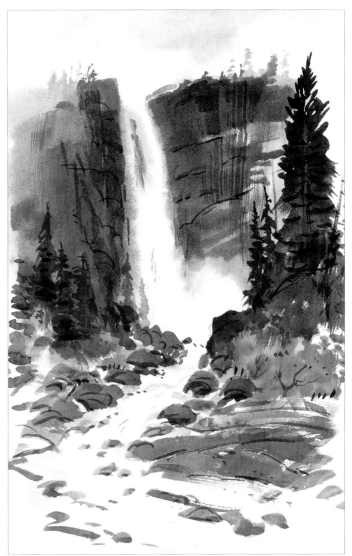

ACTION PLAN FOR SKETCH

showing the full force of the water — pastel

This is a side view of Nevada Falls in Yosemite National Park. There is so much water pouring over the ledge that it is like a spume. I chose to show a thin line of pure white against shadow and contrast it with dark rocks on either side. I have not shown the falls striking the bottom because I wanted to feature just the force of the falls. Notice that the falls divides the dark surrounding rocks into two different areas. The tall trees pointing upward serve to contrast with the falling water.

ACTION PLAN FOR SKETCH

focusing on the spray at the base — watercolor

This is also Yosemite's Nevada Falls but this time from below. Again, I divided the dark rocks with the light falls, but here I wanted to show the base where the water strikes and sprays upward. The base becomes the center of interest because of the contrast between the dark rock on the left against the pure white spray. If I had made the entire falls white, I would have lost this effect.

"Remember, shadows are always transparent."

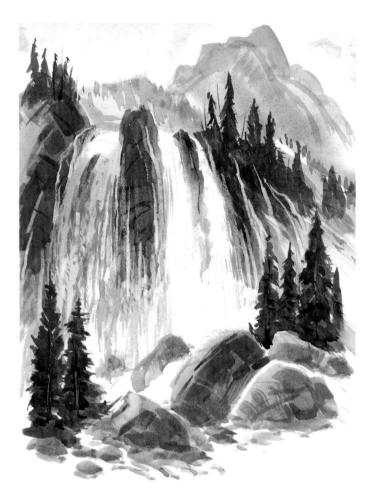

using scale to exaggerate the height of multiple falls — watercolor

Sometimes falls are broken into several drops by jutting rocks at the top. In this example from a falls in the Sierra, I again highlighted the focal point with light and shadow. This falls would look only three or four feet high if it were not for the trees. The trees also give dimension through contrast. The foreground trees are full-grown and already make the falls look huge, but the smaller trees at the top define the distance by making the top seem much farther away.

keys to waterfalls

- Learn the basic waterfall forms.
- Make one area the focal point.
- Cast shadows for interest and color.
- Preserve whites.
- Show rock color through falls where appropriate.
- Create contrast with flow and trickles.
- Show the properties of the water.
- Use scale to show height.

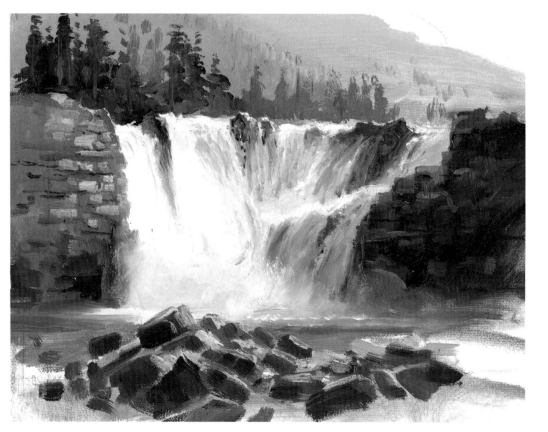

making horizontal falls look wide through design and light — oil

Not all falls are vertical. Some, like Niagara Falls or this falls in Montana, are spread over a horizontal area and are wider than they are high. Here again, notice how I used light, shadow and color. Sometimes shadowed water can take on a green or a blue color. This example also indicates scale through the size of the trees.

understanding rocks in strata and curvilinear falls

strata
The upper rock form is composed of horizontal strata, or lines. It is similar to a well designed rock wall. When painting these, be sure to underscore the lines with shadow and highlight the lines with light.

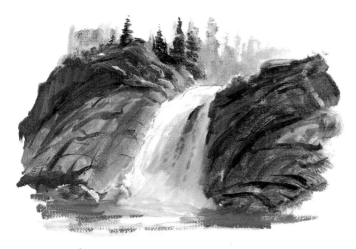

curvilinear
The lower example is one of a folded rock mass and has moving or curved lines. This too is shown by using cracks and crevasses highlighted with light and underscored with shadow.

understanding boulders and slabs

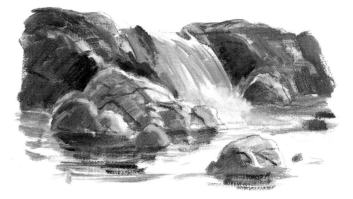

boulders
Very simply, boulders are rounded rocks and they are most common around moving water. They have been ground down by eons of smaller rocks being forced over them by the water.

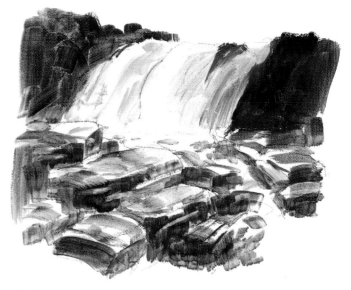

slabs
Slabs are broken off chunks of strata rocks and still have a box-like or squarish shape. The edges haven't been worn down enough to make them boulders. You may find other examples of rocks besides these, and the rocks in your region may be quite different, so study them carefully. They are the supporting base for all waterfalls.

a note about rocks

The rocks, or the base of material under and around a falls, will vary from place to place. They will also have different colors according to the terrain, but the main thing to look for is their construction. Here are four different types of rocks.

handling sunlight and shadow in a waterfall — in watercolor

NOTE!

Before you pick up your brushes, read through the entire demonstration so you know what is going to happen, and where to preserve the white of the paper. Once white paper is lost in watercolor you can't easily get it back!

ACTION PLAN FOR EXERCISE

In this demonstration you will be trying a number of the aspects of waterfalls just studied. This painting will be a waterfall with a large force in a vertical format. The background will fade out so the attention will be on the falls. The rock formation on either side is curvilinear but there are boulders at the base of the falls. You will leave some of the falls in shadow and but more in sunlight, and you will see how to enhance the scene with logs and branches using masking tape.

what you will need

watercolor palette

CERULEAN BLUE	MAGENTA	BURNT SIENNA

HOOKERS GREEN	PHTHALO GREEN

We will use a limited palette of only five colors plus the white of the paper. Mixing these five in various ways will produce a painting that looks as if many more colors were used. The colors are: Cerulean Blue, Magenta, (I could have used Alizarin as a substitute), Burnt Sienna, Hookers Green, (I prefer the darker version), and Phthalocyanine Green. Be careful when you use Phthalo because it is very potent!

brushes
1" flat brush
½" flat brush
#8 round sable or synthetic

#1 pencil
masking tape
sharp knife

paper

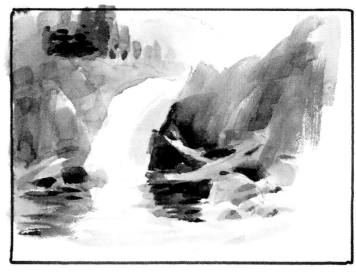

value composition
I make a few sketches to indicate the values; placing the light, the dark, and the medium values for a pleasing composition.

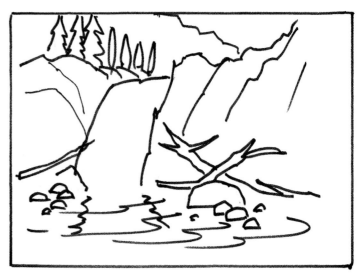

outline
I make a few outline sketches until I find one I like. Remember, the artist is the designer of the scene and must decide these arrangements ahead of time. Not planning ahead will mean problems as the painting progresses.

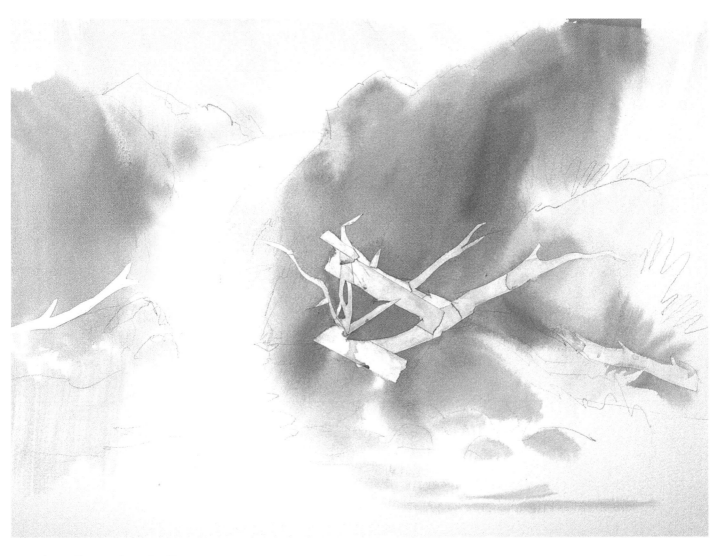

step 1: outline and mask off

First draw the outline of the falls, rocks, and logs using your #1 pencil. There is no need to draw in the details. Lay masking tape over the logs and branches and cut away the unwanted part with a sharp knife. Once you are satisfied with these steps you can mix some of the colors you will be using. Test the colors on a separate sheet of paper and then you are ready to begin.

Wet the paper with a sponge and using your 1" flat brush lay in Cerulean Blue and Magenta as a base color on the right side. Paint right over the masking tape. On the left, underpaint with a mixture of Burnt Sienna and Cerulean Blue for the base color of the rocks. While the paint is still wet, charged the colours with dabs of more Magenta and Burnt Sienna. These dabs should be made with less water so they flow into the base color. Make sure you don't apply color over the white portion of the falls. Keep them pure white, ready for later work.

BURNT SIENNA CERULEAN BLUE MAGENTA

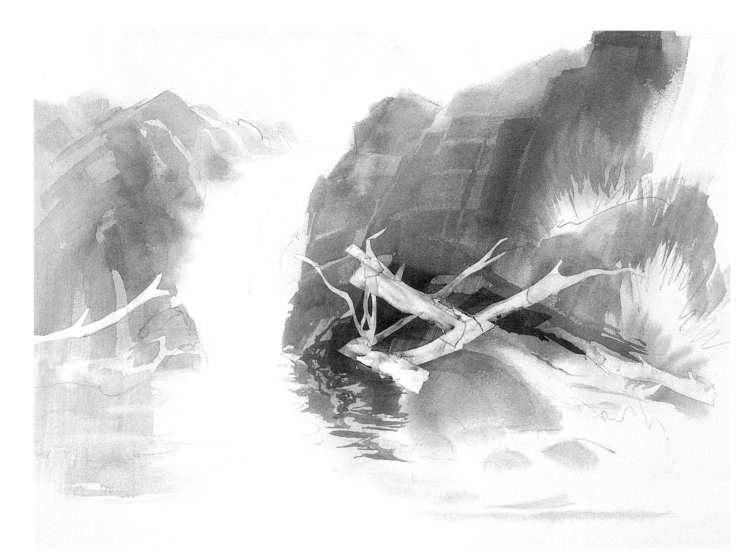

step 2: rock structuring

As the paper begins to dry dip your 1" flat brush into the same colors but with less water so they are slightly darker than the underpaint. Then lay in the blocks of rock slabs, both horizontal and vertical. Using the same colors, apply some reflections in the pool below and darken the area behind the logs. Notice I did not cover all the base paint. I left the lighter color in ways that will suggest light or reflected light. This is the beginning of creating the structure or form of the rocks.

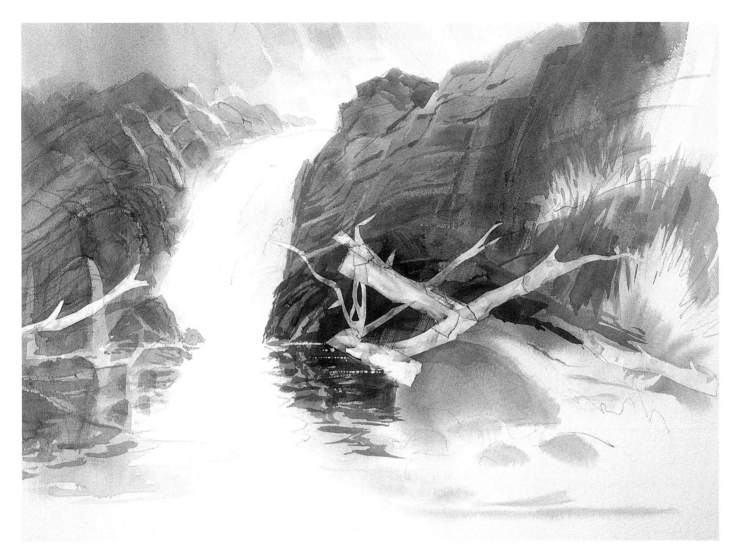

step 3: linear patterns on rocks

Switch to your ½" flat brush which you can use to make smaller broad strokes or, turn sideways to create linear work.

Using the same colors but even less water, you now have a dark paint to indicate lines. Next, mix Hookers Green and Magenta with a little water for a rich, dark color which you will use to underscore the slabs and forms that appear as shadows. Be careful to show rounded, as well as flat forms. When this is dry, apply more shadow on the left side using Cerulean Blue and Magenta. Now the two sides are the same formation but divided by light and shadow.

HOOKERS GREEN MAGENTA CERULEAN BLUE MAGENTA

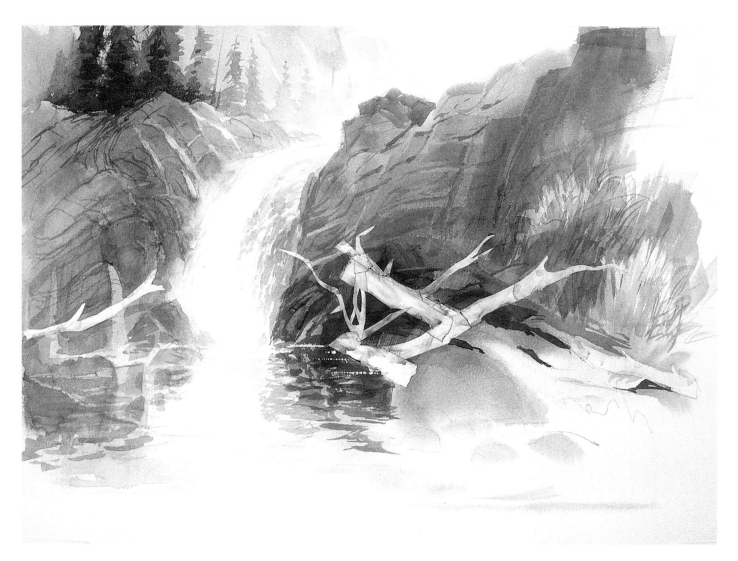

step 4: falls and foliage

Begin work on the falls using a #8 round sable or synthetic brush with watered down Phthalo Green and a touch of Cerulean Blue. (The Cerulean takes the unnatural look away from the Phthalo.) In both the light and shadow areas make strokes indicating the falling motion of the water. For the strokes in the sunlight area use more water so the color is much lighter. Leave white paper with no added strokes for the brightest effect of sunlight. Add the same colors for reflections in the pool below the falls.

Mix Hooker's Green and Magenta for the trees, using more green than red. Underpaint them beginning on the left using a dark version, but allow them to fade to the background by using more water and introducing blue. As soon as it is dry, go over the underpaint with darker strokes, indicating branches. Don't add this kind of detail to the trees in the distance. You will need some green on the right for balance, so add some grass and a hint of foliage on that side as well.

PHTHALO GREEN CERULEAN BLUE

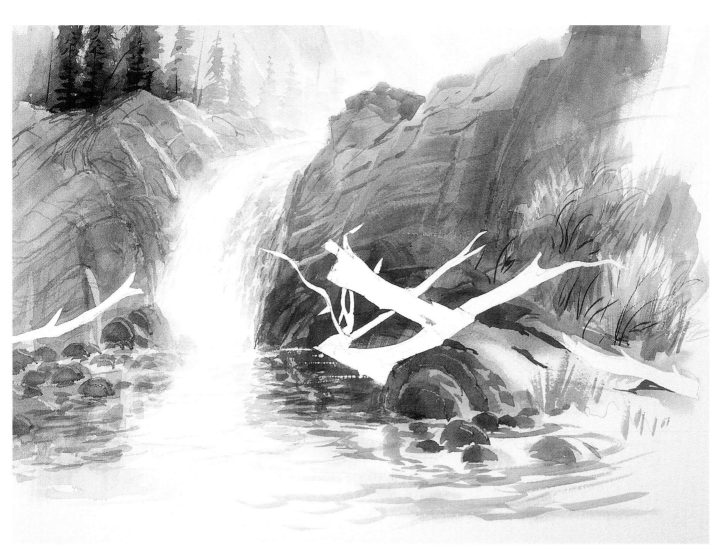

step 5: detailing the foreground

I recommend the point of a good sable or synthetic for detailing and in this case the #8 has the perfect point when wet. Go back to a dark version of Hookers Green and Magenta and add a few more dark strokes to the background trees. Do the same for some of the foreground grasses. You will need to do some more refining of the large rock mass on the right, but with a mix of Burnt Sienna and Cerulean Blue, and add a few more shapes. Do the same on the left. Introduce some of this color down to the reflected area of the pool, but with more water for lighter strokes. Some of the strokes should be curved to indicate motion. Make sure that the pool area is left as white paper where the light falls and reflects.

Finally, when you are sure all the paint is dry, pull the masking tape, leaving bare white areas to be finished next.

BURNT
SIENNA

CERULEAN
BLUE

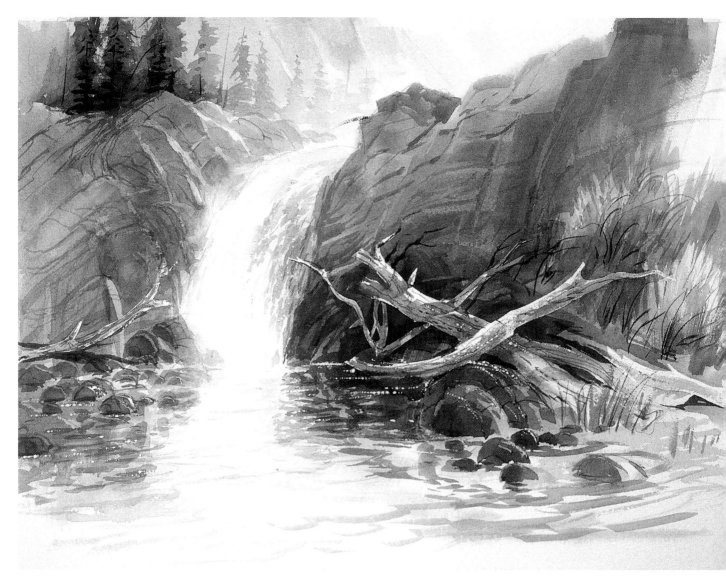

step 6: detailing logs and branches

The waterfall is the center of interest so you must make sure the logs don't detract from it. That means you have to put most of them in shadow. Remember, shadows are always transparent. Unlike earlier examples in this book where shadows were either brown or at least very dark, you should be able to see detail in them. Use Cerulean Blue and a touch of Burnt Sienna for the shadow color and leave the white paper only where you want the logs to be in sunlight. When the colors are dry, use the tip of your #8 brush and add cracks and

textures. Again, use the same shadow colors but with less water to make them slightly darker. You can improve the details by coming back in with the point of a sharp knife and scratching a few sparkles in the water. You can also extend a couple of branches so they aren't all the same.

I called my finished painting, "Mountain Falls", watercolor, 15 x 22 " (38 x 56cm).

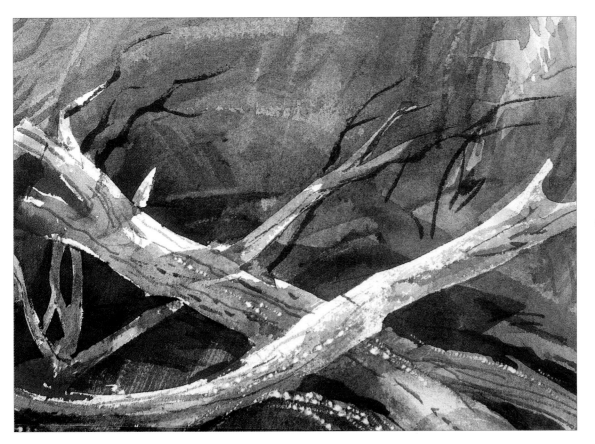

detail

detail

bays and harbors

Because they reflect the sky, the important thing to remember about these busy places is to reflect the sky first, then introduce the other objects.

Bays and harbors are protected from the high energy of the sea. Often, breakwaters are built to stop waves from entering, keeping the inner water calm. Bays and harbors offer you opportunities to reflect boats, piers, buildings and people, and you can achieve wonderful moods. There is also the opportunity to show action, because there always seems to be some form of activity going on in harbors that can be shown in different ways. For example: a boat simply anchored in calm water is reflected nearly as a mirror image and there is little or no movement. A boat with figures in it suggests more activity, and the water beneath the boat can be active enough to distort the reflections, therefore adding to the illusion of activity.

Even though harbor water can sometimes be quite choppy as a result of wind or the movement of boats, it is never as choppy as the open sea. You must choose just how much activity you want to go along with his subject.

For the most part, bays and harbors reflect the sky so the artist must first reflect the sky and then reflect the other objects. Again, there are many choices: a cloudy, overcast day can make the sky nearly white and will reflect the same. Other objects will reflect themselves over it. On other occasions, you might want to break up a large, uninteresting area of water so you will opt for a cloudy sky that will reflect into that problem area. You can make lots of choices. You are the director, and it is best if you work out as much of these options ahead of time to avoid problems while painting.

(Right) *Listing*, **watercolor, 24 x 30" (61 x 76cm)**

ACTION PLAN FOR SKETCH

reflecting the subject in nearly quiet water — oil

Let's assume it's an overcast day and the harbor water is relatively calm. In this case it will reflect the whiteness of the atmosphere. Boats, piers, and buildings will then reflect with a lot of contrast. If the water is deep, the reflections may be darker than the objects above. If the water is somewhat shallow, light may be able to penetrate the water and bounce back toward the surface. This could make the reflections a bit lighter than the objects. In this example, the reflections are darker due to deep water.

ACTION PLAN FOR SKETCH

introducing action and rippled water — oil

This sketch shows the same theme with the same atmosphere. The difference is that some activity has taken place. The posture of the man in the boat suggests action, and the reflections are broken up by his boat passing through them. Two things have happened: first, the reflections have been altered, and second, the altered reflections add to the theme of activity — the mood — of the scene. If the man was merely sitting in his boat, then rippled reflections would not reflect his inactivity.

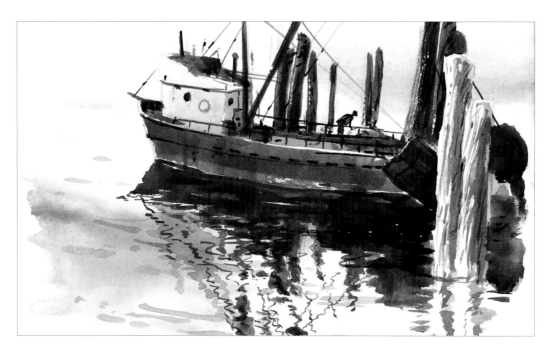

suggesting activity — watercolor

This boat sits in fairly calm water, but there are some ripples and the sky is reflected in them. The boat is not underway so there is little activity as far as it's concerned, but the solitary figure is busy at something. With this in mind, it was a good choice to show some action in the water, but not too much. Here, the slightly rippled water breaks up the reflections of the rigging just enough to match the activity suggested by the man on the boat.

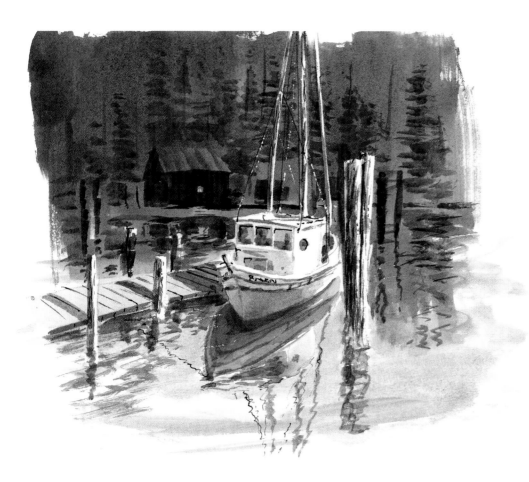

understanding reflections seen from above — watercolor

This is an example of a boat in fairly shallow calm water. Instead of reflecting a mirror image, two things are changed: First, the boat hull's reflection is green instead of its actual blue color. This is because of the shallow water and the shadow being cast by the boat. Second, there is more boat reflection than our eyes see. That is because we are looking from above — the water acts like a mirror revealing the underneath parts of the boat that our perspective doesn't allow. It is much like holding a mirror beneath your chin; you can't see under your chin but the mirror can, and you can see the mirror.

ACTION PLAN FOR SKETCH
Breaking space with sparkle and glare — opaque watercolor

The reflections of the sun may cause bits of sparkle like tiny, bright lights or it may spread out as glare and be hard to look at.

Using either one is a nifty way to break up space that might be too much the same and/or boring. You can also use sparkle and glare to make a boat or other object stand out, or to simply add texture to a painting. This example was done using white paint. See the accompanying exercise which shows you how to do this.

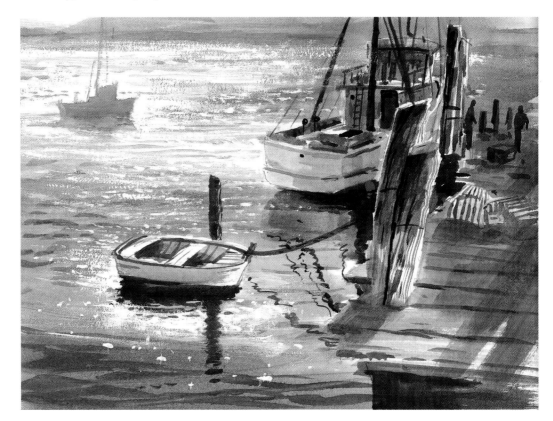

painting sparkle in 3 steps

This approach can be used with any medium except pure, transparent watercolors, where you can try picking out sparkles with the point of a knife or dry-brushing color over rough textured paper.

base colour

overlay white

add white and darks

1. Begin with a base color of your choice.

2. Overlay white, but give the outer edges a scattered effect.

3. Go back over the white area with a few darker chops or ripples, and add some more dots of white on the outer edges for sparkle.

creating outer harbor reflections — opaque watercolor

The entrance to a harbor, sometimes called the bar, can be quite active, but is still calmer than the open sea. This water gives you the chance to reflect sunlight and objects differently from the way you would paint harbor water. After laying in a base of colors, add white ripples and color from objects such as a boat over the surface. See the accompanying illustration.

IMPORTANT NOTE
The strokes you use will show the contours of the chops or swells. With this in mind, you can create any type of activity you wish, from low rippling to very choppy water.

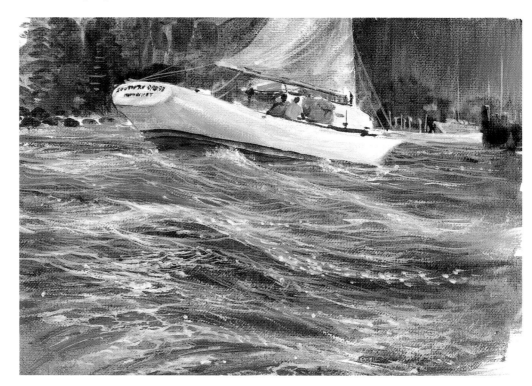

step 1

base colour

lines must touch others

how to reflect chops — opaque watercolor

This is almost the same as in a previous chapter, but in this case I want to stress the importance of varying the base colors. Water is seldom all the same color, especially in the surf or near a harbor. Because of shadows, underwater rocks and plants, and how the sunlight penetrates it, water can vary from various green colors to different shades of blue and even purple. Therefore, paint the base color of water with some variety and then go over this with highlights that create chops, swells, ripples, or sparkle.

IMPORTANT NOTE
Make CHOPS touch one another. Swells may touch also but in the background they may appear separate.

step 2

ACTION PLAN FOR SKETCH
piers and buildings — watercolor

Piers and buildings offer unlimited ways to reflect themselves. They also add to a painting's mood. Again, you choose. If your composition needs a repeat of a color for balance you can choose to do it by reflecting something in the water. If the composition does not need that color repeated, you can obscure the reflection in water in several ways: The water could be too choppy to reflect, there could be an object such as a boat in the way, there could be glare or glitter from sunlight that blocks the reflection, or the reflection of a dark or a light cloud could dilute the reflection so it is not as strong.

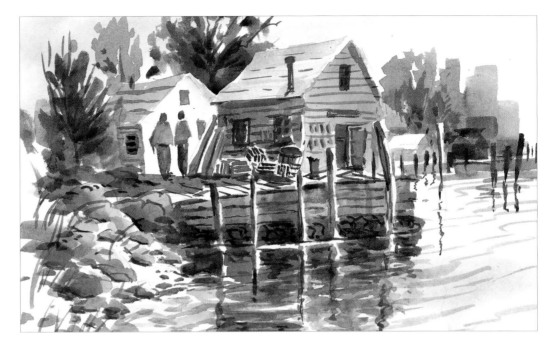

ACTION PLAN
FOR SKETCH
suggesting a harbor in moonlight — oil

I added this sketch simply to show you that you can create any mood you wish with any scene. This view of a harbor could have been daylight, morning, high noon, during a storm, or just about anything else. I repeat once again because it is so important — the choices are up to you.

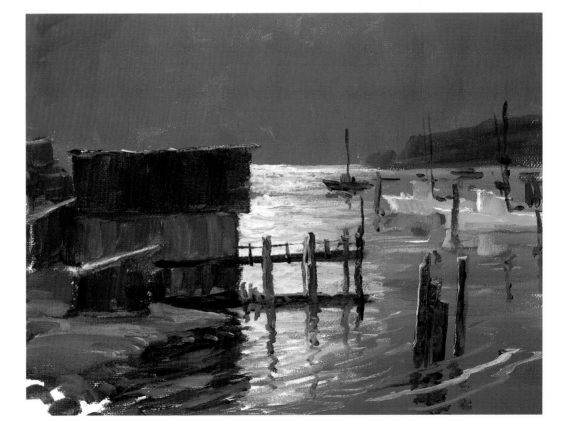

art in the making **suggesting downlighting in a busy harbor scene using oils**

Before you begin this painting, take the time to read the captions through carefully so you know what you will need and what is going to happen next.

what you will need to do this exercise

oil palette

ULTRAMARINE
BLUE

SAP GREEN

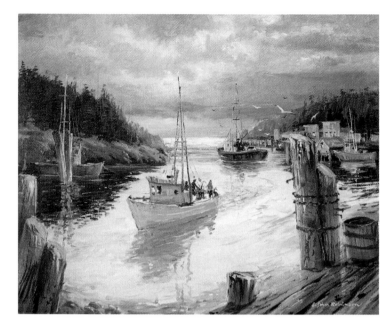

CERULEAN
BLUE

BURNT
SIENNA

ALIZARIN
CRIMSON

TITANIUM
WHITE

canvas board or paper

brushes
#8 filbert
#4 filbert
2" hazing brush
#0, #1, #2 round sable or synthetic brushes

painting medium

tonal value plan
Here's how the painting looks in shades of gray.

step 1: make an outline
Once again use thinned Ultramarine Blue for the outlines.

NOTE
An option you could consider another time is to underpaint the entire canvas with either a warm or a cool color to set the mood. Thin the color and wash it on, then wipe it down. This will allow you to begin painting immediately, and if some of the paint bleeds through that is OK because it acts as a theme tone for all the colors.

step 2: start with the backlit sky

Beginning with the sky allows you to set the values and the atmosphere which will be reflected in the water. Outline the edges of the clouds with pure white in the area of the sun, then use Cerulean Blue with white for the sky behind the clouds. All of this can be scrubbed in with a #8 filbert brush. Then use Ultramarine Blue into white for the shadowed areas of the clouds. When all the sky is brushed in, go back and add some more white, then brush it all down with your 2" hazing brush. (You will notice that I lowered the group of trees on the left by bringing the sky further down. I didn't like the way it would have looked. Feel free to make whatever adjustments you choose if you think it will look better.)

step 3: introduce the background hills

With a #4 filbert lay in pure white for the sea at the horizon line, then mix Ultramarine Blue and some Cerulean Blue into white for the distant headlands. This shows the atmosphere has an effect on distant color. Next, paint the tree-covered headlands using Ultramarine Blue and Sap Green. For the distant buildings use Burnt Sienna and white applied with your #2 flat brush. Finally, reflect these colors into the water, but darken them with Alizarin Crimson and more Sap Green. This completes the background.

ULTRAMARINE BLUE SAP GREEN

111

step 4: paint the harbor water

Using the #8 filbert, paint all the light areas of the water using pure white. Then with a #4 filbert, reflect some sky color — Cerulean Blue and Ultramarine Blue softened into the white underpaint. Next, haze it so there are no hard edges. Hazing softens the edges giving the water a smooth, mottled look. Remember, because we are looking down on the water the sky reflections are overhead and can be different from the sky within the composition.

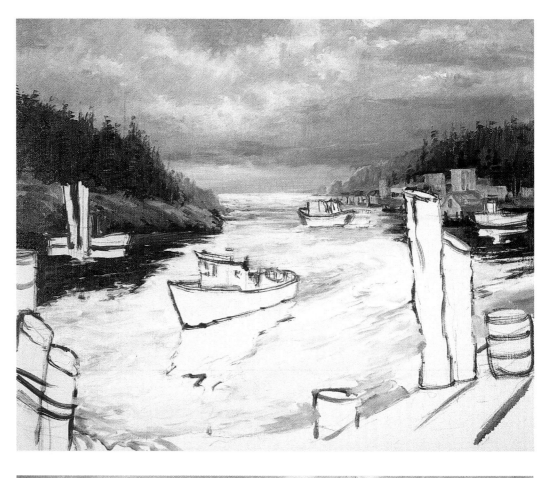

step 5: underpaint the boats and piling

Use a smaller flat brush and underpaint the boat on the left using Cerulean Blue. The farthest boat has an upper stripe of Cerulean Blue. Paint its hull using Burnt Sienna. The right boat and the central boat can be underpainted with Ultramarine Blue into white. The reflected color of the central boat is a combination of Cerulean Blue and touches of Sap Green into the white underpaint. The pier and all the pilings are Burnt Sienna with some white. Next, add some Ultramarine Blue and white for variety. Remember: It is best to vary all your colors rather than using only one for each object. Varying colors adds interest and if done correctly will not change the base color more than you wish.

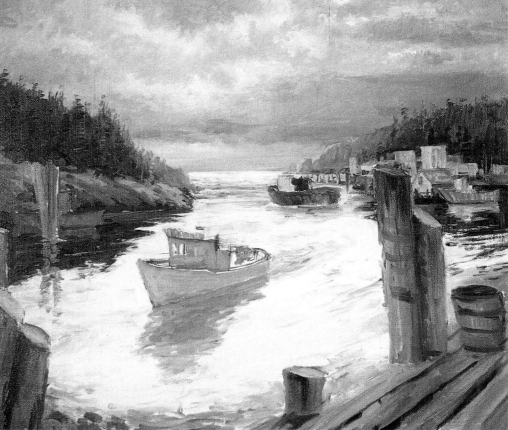

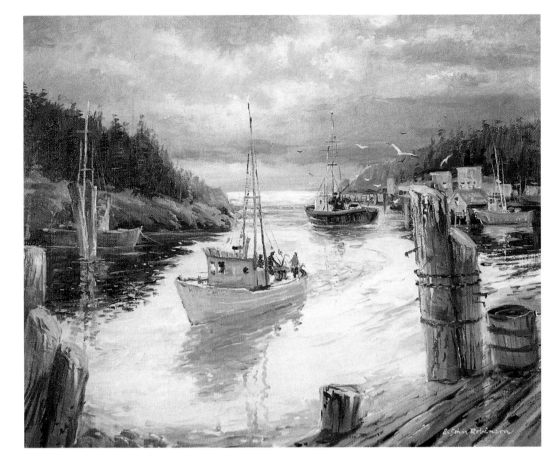

step 6: detail the foreground

For detailing all the lines and textures use the #'s 0, 1, and 2 round brushes. The masts are Burnt Sienna with touches of white. For darker lines such as the cracks on the pier use Burnt Sienna darkened with Ultramarine Blue. Add figures, lines, small objects and textures using any colors found on your palette. Note that the seagulls are white where the light strikes them and darker in shadowed areas.

evaluating the finished work

The overall effect is a harbor scene with bright downlighting. The mood is one of calm safety, which is emphasized by the boat just coming home from the dangers of the sea. For contrast, there is a boat about to leave, which gives the painting a sense of activity. I kept the colors cool to go along with the feeling of a quiet sanctuary.

I call this "Northwest Fishing Harbor", oil on linen canvas, 16 x 20" (41 x 51cm).

keys to bays and harbors

- You can set a variety of moods, including refuge, relaxation, preparation or triumph.
- Figures assist feeling of activity.
- Bays and harbors reflect the sky so you can choose the color and reflections.
- You can use calm water, ripples or wash from leaving and entering boats.
- You can introduce docks, piers and jetties for interest and narrative.

chapter 11

the surf

The sea is the greatest reflector of all, and it allows you to paint countless moods.

Currently, I have two books out which are entirely devoted to all the different ways to paint the sea; one in oils and the other in watercolor.* Therefore I will not go in to great detail in this chapter. Instead, I will concentrate on passing on some good basic knowledge. Then I'll show you how to put the basics together.

The sea is perhaps the greatest reflector of all; not only of colors and objects but of moods. I think just about any mood that we experience can be shown in the sea. When you understand the workings of the surf and combine that knowledge with color and values you can depict countless moods. I have seen waves that angrily bash at rocks and bluffs, and I have seen waves so gentle a toddler could play in them without fear. I have seen waves that seem to tumble over one another in a frolic to reach shore, and waves that looked peaceful but which rose up to smash boats and piers. Sometimes waves take their time to reach shore and at other times they dash and race as if they can't get there fast enough.

Careful use of color and value compositions can make the surf appear sad or happy, lonely or crowded, moody, depressed,

Power of the Sea, watercolor, 24 x 36" (61 x 91cm)

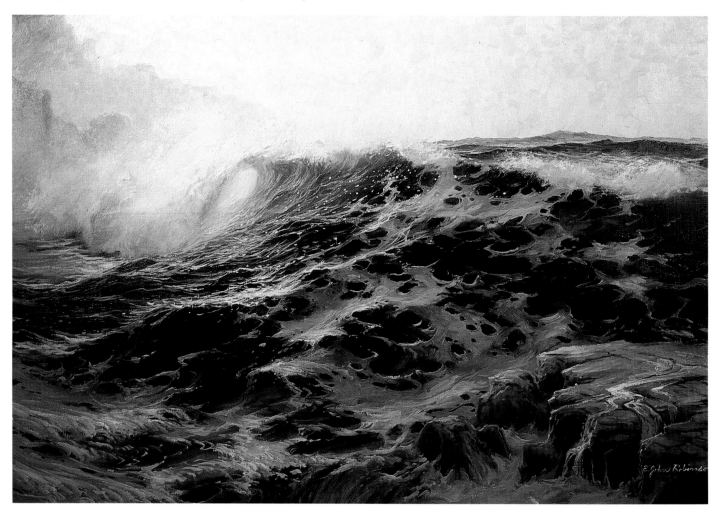

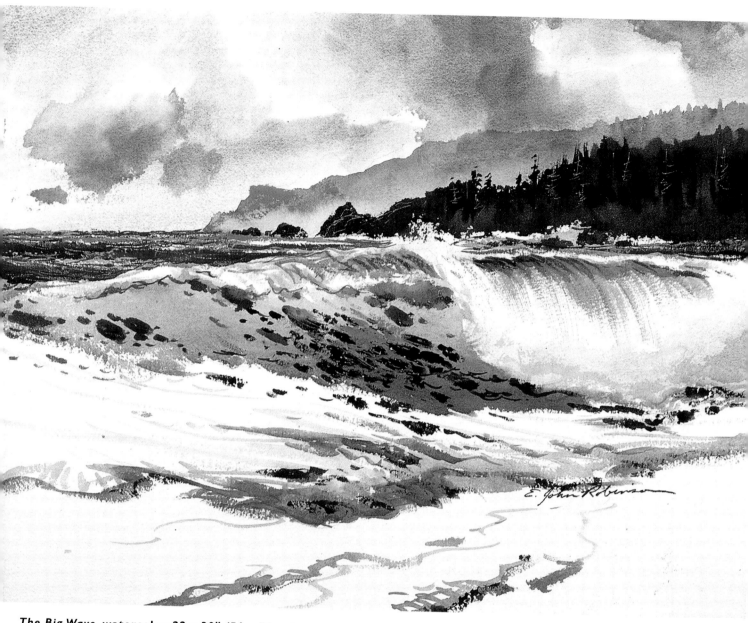

The Big Wave, watercolor, 22 x 30" (56 x 76cm)

uplifted, restful or neutral. As I have been saying throughout this book, pinpointing and suggesting mood may be more important than values and colors. Not understanding the mood could mean sending the wrong message. For example: You want to paint a restful scene at sundown. Horizontal lines are the best way to do this, but because the actual scene has a headland covered with many pointed trees which you include, you end up with a nervous line that fights against the restful, horizontal ones. The viewer won't know what the mood is. Choose the mood, then decide what to use and what to leave out of the scene.

Learn the basics of the sea and work to master them, but always be aware of the contribution that line, value, color and their combinations do to create mood.

* E. John Robinson's two definitive books, "Paint the Sea in Oil Using Special Effects" and "Paint the Sea and Shoreline in Watercolor Using Special Effects", are widely available from all good bookshops or by ordering via International Artist Publishing's website: **artinthemaking.com**

the basics

basic swells

Swells are not breakers but they sometimes have foam riding on their leading edges and lines of foam climbing up the face. Swells represent the uplifting of the surface by the moving energy below and they are usually too thick for light to pass through. Therefore, swells seldom have the translucent look of a breaker. It is important to know how to paint them because they are seen just behind breakers and, as they travel to shallow water, they build up too high to support themselves and crash forward. The swell then becomes the breaker. Swells have miniature swells on their surface that reflect the sky or foam. The trick to painting them is to make each mini swell touch or connect to another as shown in the inset. If they do not connect they can look like worms swimming across the face.

basic breakers

In this illustration notice the swell behind the breaker. As it comes forward it will become the next breaker. The breaker has an area at the top and near the curl-over that is thin enough for light to pass through. It is translucent water but should not be shown that way clear down to the base because the base is too wide for light to pass through.

Notice the curl-over. It starts out as clear water but as it falls forward it mixes with air and creates foam. A foam edge should never be hard-edged because it is flying mist. Notice the inset. It shows that the curl falls down and forward while the wave face is actually rising upward.

basic foam lines

When a breaker collapses it creates frothy foam that is like a blanket if heavy enough, but thins out as linear patterns after a few moments. In this illustration notice how the lines of surface foam ride up and over the foreground swell (a backwash) and then up the curved face of the breaker. Do not show all these patterns in white because it will become monotonous. Place some foam in shadow and some in sunlight as shown here. You can choose exactly where you want them to be.

mass foam

This shows a wave more collapsed than the previous ones. The surf below it is a blanket of foam caused by the last wave that came in and collapsed and there hasn't been time for it to dissipate into lines. Only a few holes in the foam show the color of the water below. Again, it is best to have some foam in shadow and some in sunlight. You can use any excuse you want for casting shadows — a bluff outside the composition, clouds or large, unseen rocks.

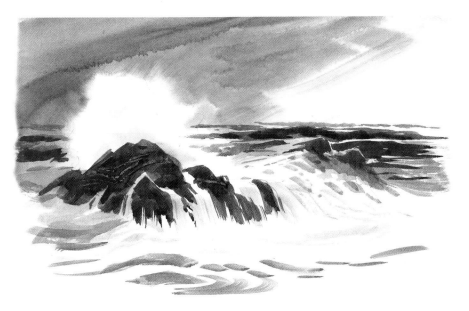

rocks and spills

There are often rocks of many shapes, colors, and sizes in the surf. They add the element of earth to the composition of sky and water. This illustration shows a burst of water on the left from a wave that has just hit. The right side shows an overflow of foamy water from a wave that has passed by. The main rock shows trickles after an overflow has nearly gone. Remember, water seeks its own level and will take the easiest path to reach it. Therefore, the spills and trickles will find their way to the surface in cracks and crevices.

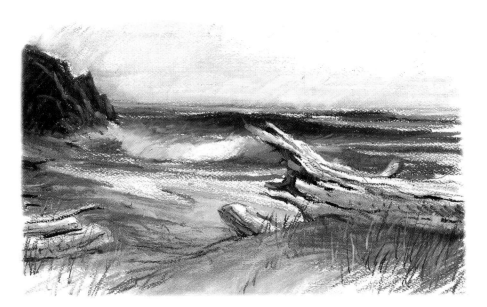

beaches and driftwood

Beaches, like rocks, add the element of earth to the composition. They are just as important as the sea, but you must decide if you want a seascape or a beachscape. One must be more important than the other because you should not have two stars on stage at the same time. In this example the breaker is the center of interest even though the water takes up less space than the foreground. What gives the breaker more interest is the sunlight hitting it. Both the beach and the driftwood point to it. Notice also that the beach has curving lines, much like swells. This is another way to put the two elements in harmony with each other.

117

putting the basics together

ACTION PLAN FOR SKETCH
suggesting mood with stormy motion — oil

Here is a sketch to show how a mood can be depicted. I painted a good-sized breaker to show a lot of energy, and placed it so it is aimed at a large rock. The slant of the rock is such that it appears to be leaning back, as if retreating from the coming deluge. The sky is dark and its angle shows movement that seems to be pushing the waves shoreward. The sky and the sea work together to pound at the earth, and only a spot of sunlight keeps the mood from being totally menacing. The inset shows the motion lines of the composition.

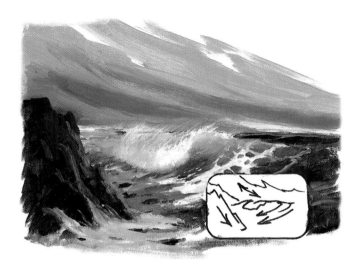

ACTION PLAN FOR SKETCH
suggesting mood with warm light influence — oil

Here is a much happier mood. On a west coast this would be morning with warm light flooding in from the right. Even though the wave is large enough to be the result of a storm, it isn't threatening the rocks and isn't in conflict with anything. The warm sunlight spreads its influence over the sky, part of the wave and foreground. Here again, the use of shadows prevents the scene from being overwhelmed by the same warm colors.

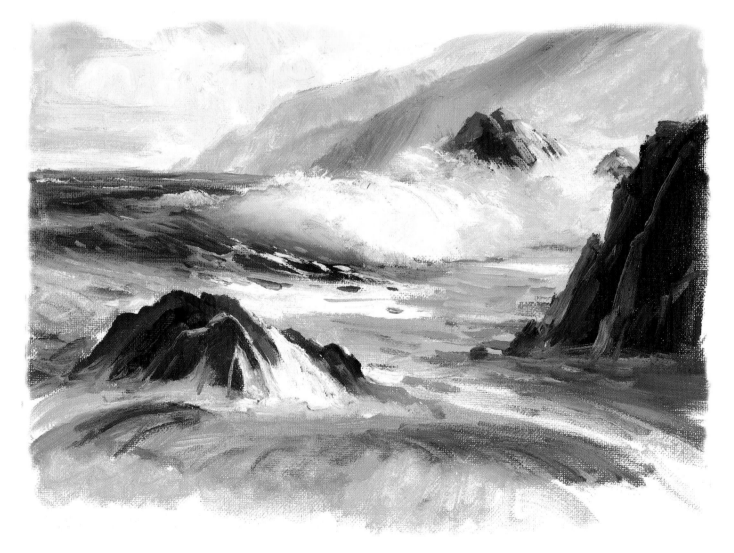

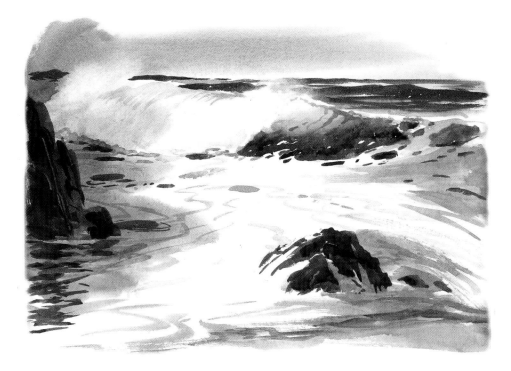

ACTION PLAN FOR SKETCH

using sunlight and shadow to create the effect of a bright day — watercolor

Here is a combination of a breaker with a translucent area with swells behind it. Part of the wave is in shadow and part in sunlight. The foreground is blanket foam but there is a bit of linear foam on the wave face. The rocks have a supporting role because they cast shadows as well as break up space in the composition. The foreground rock also shows the trickles left from a former overwash. There is just enough motion in the surf to give it some animation. It is a bright day with lots of sunshine and the mood is one of energy and light.

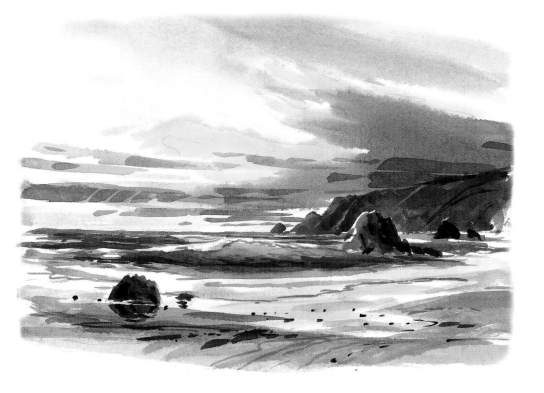

ACTION PLAN FOR SKETCH

combining color temperatures for a quiet sunset — watercolor

Sunset is out over the horizon line on a west coast and it depicts the end of a day, a time to stop activity and to relax. By combining warm and cool colors, basing the composition on mostly horizontal lines and showing a very small, non-threatening wave, the mood is exactly what was intended. Had I used too many rocks in the foreground, made the clouds too busy or the sky too dark and threatening, the quiet mood would have been lost or overwhelmed by another mood.

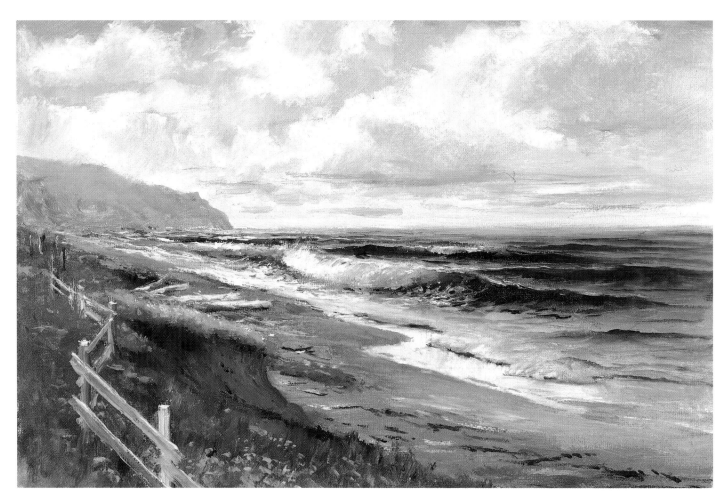

ACTION PLAN FOR SKETCH

introducing mood into a panorama — oil

When we stand above the sea, well away from the action, there is no threat of its potential power. We stand safe and secure. A panorama may take in any amount of shoreline, which not only depicts the sea, but also beaches and bluffs. In this example, even a fence adds to the security of the scene, but there's a hint that one day the sea may find its way to the fence as well. Nothing is forever.

I chose to show a vast area fading into atmosphere with a warm foreground and a cool background. It is a beach where one may walk in relative comfort, feeling the energy of the sea, remembering things past while making new memories. It is not a lonely beach because it invites your presence.

"Pinpointing and suggesting mood may be more important than values and colors. Not understanding the mood could mean sending the wrong message."

art in the making **moonlight reflecting off translucent waves — in oil**

Before you begin this painting, take the time to read
the captions through carefully so you know what you
will need and what is going to happen next.

what you will need to do this exercise

oil palette

ULTRAMARINE BLUE

SAP GREEN

LEMON YELLOW

PHTHALO BLUE

PHTHALO GREEN

ALIZARIN CRIMSON

TITANIUM WHITE

brushes
#8 filbert brush
2" and 3" blending brushes
#00 and #0 sable or synthetic brushes

step one: make the outline
Using a #2 round brush and thinned Ultramarine Blue, make a quick
outline sketch of the clouds, headlands, the major wave and foam.
Then indicate the darker foreground rocks using more blue. Never
go into detail with the outline because it will soon be covered over.

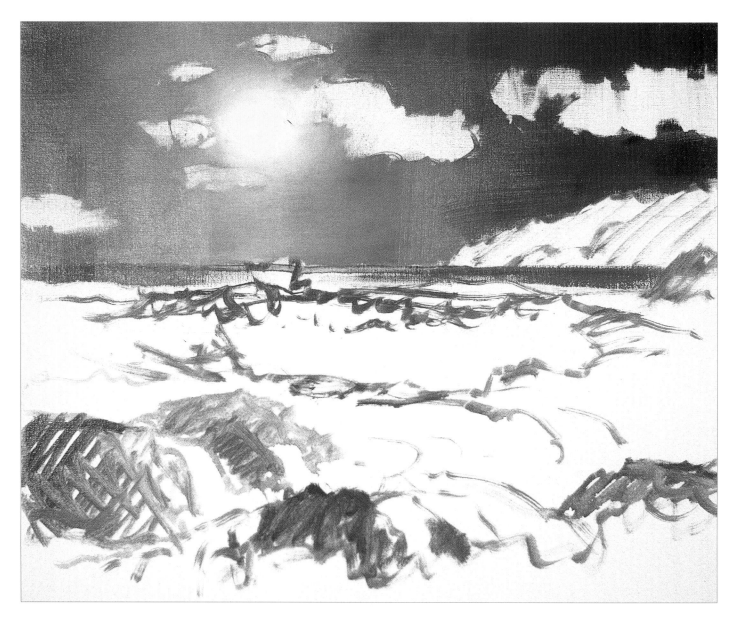

step 2: start on the background sky

Mix a small amount of Lemon Yellow into white, and with a #6 filbert brush paint the area of the moon using circular strokes. Paint the sky beginning at the outer edges and gradually lighten it as it nears the moon.

Then, using a #8 filbert brush, mix a pile of the darkest color of the sky with no white paint in it — use Ultramarine Blue, Alizarin Crimson and Sap Green. Using Sap Green may seem like an odd choice but it neutralizes the red and keeps the mixture from being pure purple. It makes a rich dark. At first apply the pure color on both of the outer edges, then gradually add a bit of white as you near the area of the moon. Leave the clouds unpainted because they will be lighter than the sky and it is hard to lighten dark paint. There will be some rough edges between applications, so blend the entire sky area using a 2" blending brush.

ULTRAMARINE
BLUE

ALIZARIN
CRIMSON

SAP
GREEN

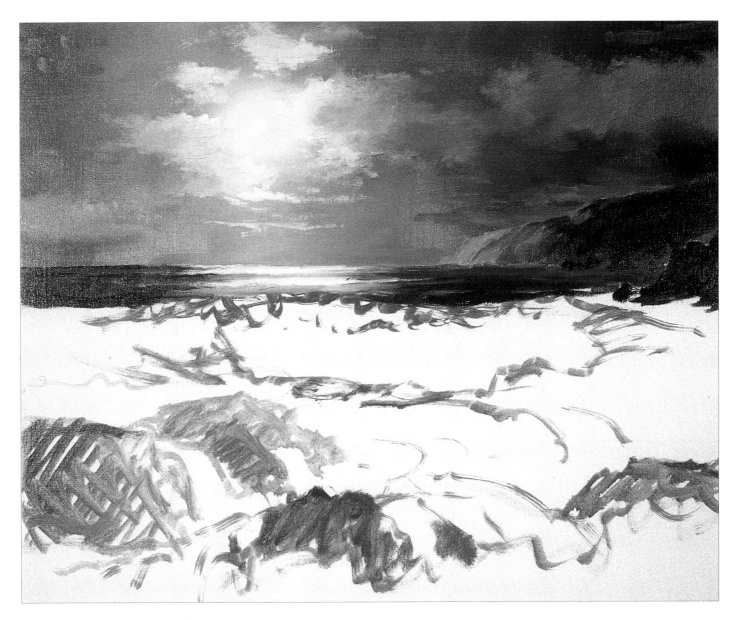

step 3: paint the clouds and background sea

Near the moon use a touch of Alizarin Crimson into white for the edges of the clouds and leave them light because of the moon's influence. Then, using a #3 filbert, scrub white into the rest of the clouds, but allow the sky color to mix in as you paint. This gives the clouds the same basic color as the sky, but much lighter. Also make sure the edges are soft and fluffy by doing some hazing.

Paint the headland the same as the sky, but using more Sap Green will make it appear darker than the clouds behind it. The background sea is also the sky color. The area of light is the yellow-white of the color you used for the moon. Paint the nearest swell with a touch of Phthalo Green to indicate that it is translucent.

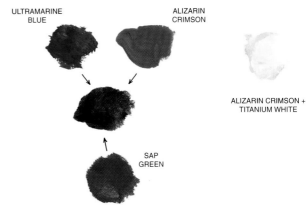

ULTRAMARINE BLUE

ALIZARIN CRIMSON

ALIZARIN CRIMSON + TITANIUM WHITE

SAP GREEN

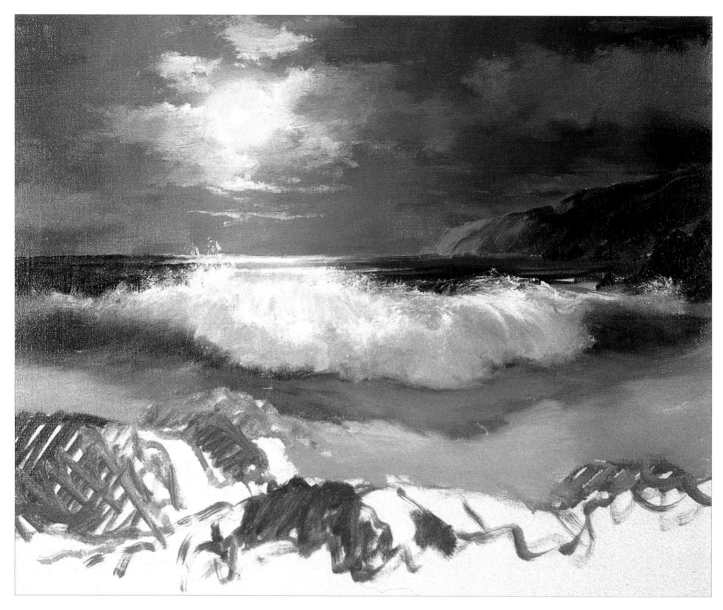

step 4: now paint the major wave

For the translucent area of the wave use Phthalo Green and a touch of Lemon Yellow into white. The rest of the clear water can be painted using Phthalo Blue and Ultramarine Blue with no white. The wave foam is in shadow so with a #6 filbert blend a bit of the sky color and a touch of the wave color into white and scrub it in. Then take the yellow-white colors used for the moon to lighten the top of the foam where the light would strike it. Use your blending brush to soften all the edges just as you did with the clouds.

The last thing is to paint the foreground foam. Use the sky color into white, but use less white for the shadow area under the wave foam.

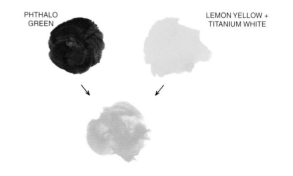

PHTHALO
GREEN

LEMON YELLOW +
TITANIUM WHITE

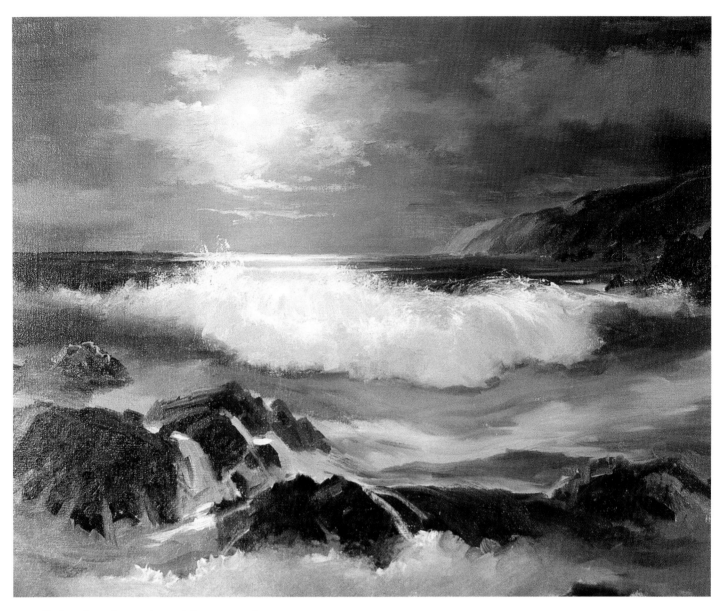

step 5: develop the rocks and foreground

For the rocks use a #6 brush and a mixture of Sap Green and
Alizarin Crimson, but just a bit more red to keep a warm color.
Highlight the rocks with the same color but add white. The dark
roll of water between the rocks is a mix of Phthalo Blue and
Ultramarine Blue. Paint the rock spills and the foreground foam
the same as the shadow foam above, then highlight it with the
yellow-white mixture. Add another rock on the far right for better
balance and also some green chops. (When you see something
that could improve balance, do it.)

PHTHALO
BLUE

ULTRAMARINE
BLUE

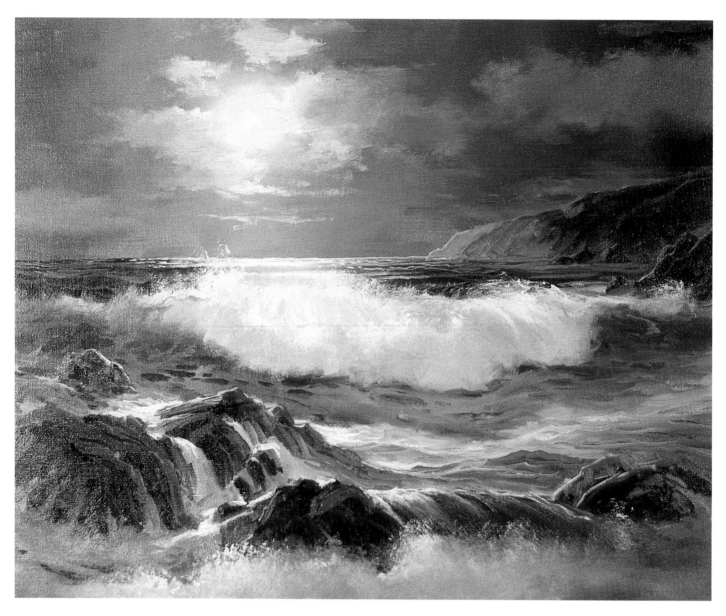

step 6: it's time to add the finishing touches
Detail with a couple of small brushes, #'s 00, and 0 sables. Using the moon color, highlight the waves, foam and foreground chops, and anything the moonlight would touch. Add some surface holes in the shadowed foam and a few darker strokes of the clear water of the wave. Finally, add some spray to the wave foam by dipping your hazing brush into some moonlight color and dab it gently above the edges. I call this "Near Dawn", oil on linen, 16 x 20" (41 x 51cm).

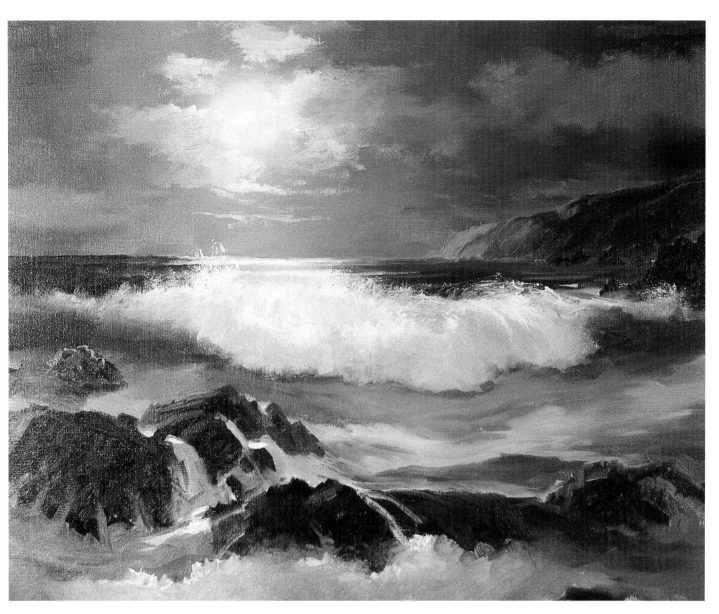

step 5: develop the rocks and foreground

For the rocks use a #6 brush and a mixture of Sap Green and
Alizarin Crimson, but just a bit more red to keep a warm color.
Highlight the rocks with the same color but add white. The dark
roll of water between the rocks is a mix of Phthalo Blue and
Ultramarine Blue. Paint the rock spills and the foreground foam
the same as the shadow foam above, then highlight it with the
yellow-white mixture. Add another rock on the far right for better
balance and also some green chops. (When you see something
that could improve balance, do it.)

PHTHALO
BLUE

ULTRAMARINE
BLUE

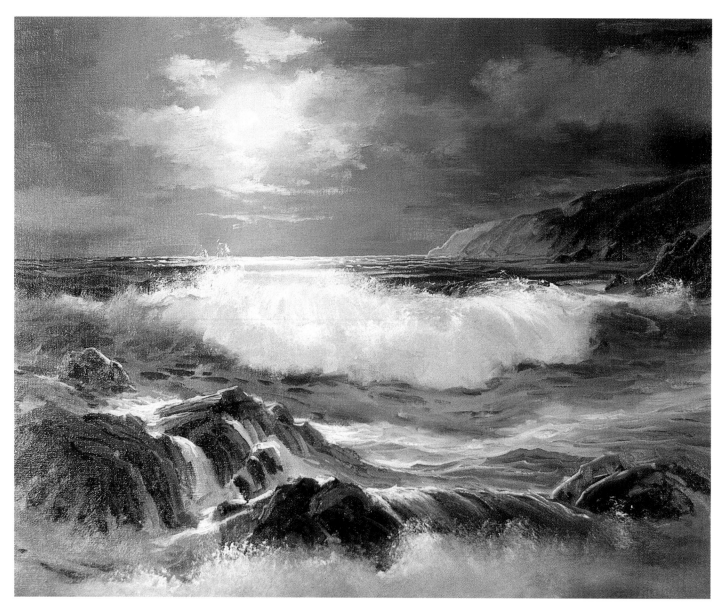

step 6: it's time to add the finishing touches
Detail with a couple of small brushes, #'s 00, and 0 sables. Using the moon color, highlight the waves, foam and foreground chops, and anything the moonlight would touch. Add some surface holes in the shadowed foam and a few darker strokes of the clear water of the wave. Finally, add some spray to the wave foam by dipping your hazing brush into some moonlight color and dab it gently above the edges. I call this "Near Dawn", oil on linen, 16 x 20" (41 x 51cm).

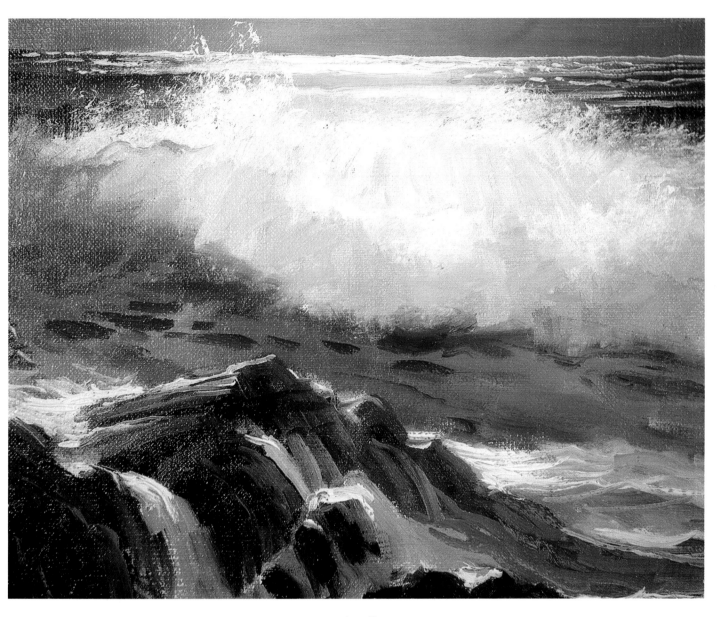

detail

keys to surf

- Swells seldom have the translucent look of a breaker.
- Make swells touch each other.
- Foam edges should never be hard-edged.
- The top areas of breakers near the curl-over are translucent.
- Introduce color in foam patterns to prevent white monotony.
- Spills and trickles seek the easiest path and will use cracks and crevices to get there.
- Decide on your mood and enhance it with color temperature, line, light and dark contrast and shape.

about the artist

E. John Robinson has always been an artist. He started out with pencils, crayons, anything he could find, until he was given watercolors at age six. He graduated to oils at age twelve and has been painting ever since. His first award came in high school when he placed among the top ten in the National Scholastic Art Contest. Since then he has avoided such contests, considering popular acceptance much more satisfying.

He went on to study art in Seattle at the Cornish School of Arts, then to the California College of Arts and Crafts, Oakland, California. He was told no one could ever make a living as an artist, so he entered education and taught in public school. However, after twelve years he was making more from his paintings than he was as a teacher so he and his family moved to the village of Mendocino, on the rugged north coast of California, where he could specialize in painting the sea. From 1960 to 1980, E. John painted only the sea and with a keen reverence for Nature that is a hallmark in his paintings. He eventually painted landscapes as well and carried the same love of Nature to them.

Today, after a long, satisfying career, he can look back on over 4,000 seascapes, most of which are in private collections, four covers for *Reader's Digest*, two instructional books "Paint the Sea in Oils Using Special Effects" and "Paint the Sea and Shoreline in Watercolors Using Special Effects", both published by International Artist Publishing and available on the website: artinthemaking.com. His work has been featured in *International Artist* magazine and he also has produced a series of bestselling art instruction videos.

E. John Robinson is acknowledged as one of the world's finest seascape artists. His paintings are in numerous private and corporate collections in America and Europe.

E. John and his wife still live in Mendocino and he continues to paint, always looking for that special moment, always reaching out, and always trying to improve.

— Ted Hendershot, Gallery owner

E. John's other books can be ordered through International Artist Publishing at artinthemaking.com